CW00505437

Cool Restaurants Berlin

teNeues

Imprint

Editor:	Joachim Fischer
Editorial coordination:	Corinna Mandic, Bianca Poppke
Photos (location):	Dirk Wilhelmy, Stuttgart (Café de France, FACIL Restaurant, Margaux, Maxwell, Monsieur Vuong, Newton Bar, Schwarzenraben, VAU, Vox Restaurant), Karl Bongartz, Berlin (Universum Lounge), Rainer Klostermeier, Berlin (Adnan, Al Dente Bocca di Bacco, Borchardt, Caroshi Bar & Lounge, FACIL Restaurant, Greenwich Bar, GUY, Kuchi, Lutter & Wegner, Manzini, Margaux, Maxwell, Newton Bar, Nola's am Weinberg, Pan Asia, Paris Bar, The Room, Vox Restaurant), Hoidn Wang Partner (Le Bar du Paris Bar), Klaus Frahm, Hamburg (VAU), Klaus Bartels, Thurnau (Kula Karma), Ingo Strobel, Berlin (Victoria Bar), Zsolt Veltan, Berlin (FELIX ClubRestaurant), Eberle & Eisfeld, Berlin (103 Bar)
Introduction:	Joachim Fischer
Layout & Pre-press:	Thomas Hausberg
Imaging:	Florian Höch, Jan Hausberg
Translations:	Ade Team, Margarita Celdràn-Kuhl / Dr. Miguel Carazo (Spanish), Dr. Andrea Adelung / Robert Kaplan (English), Birgit Chengab / Ludovic Allain (French), Jaqueline Rizzo (Italian)

Produced by fusion publishing GmbH, Stuttgart . Los Angeles
www.fusion-publishing.com

Published by teNeues Publishing Group

teNeues Publishing Company
16 West 22nd Street, New York, NY 10010, USA
Tel.: 001-212-627-9090, Fax: 001-212-627-9511

teNeues Book Division
Kaistraße 18, 40221 Düsseldorf, Germany
Tel.: 0049-(0)211-994597-0, Fax: 0049-(0)211-994597-40

teNeues Publishing UK Ltd.
P.O. Box 402, West Byfleet, KT14 7ZF, Great Britain
Tel.: 0044-1932-403509, Fax: 0044-1932-403514

teNeues France S.A.R.L.
4, rue de Valence, 75005 Paris, France
Tel.: 0033-1-55766205, Fax: 0033-1-55766419

www.teneues.com

ISBN:	3-8238-4585-3

© 2004 teNeues Verlag GmbH + Co. KG, Kempen

Printed in Germany

Picture and text rights reserved for all countries.
No part of this publication may be reproduced in any manner whatsoever.

All rights reserved.

While we strive for utmost precision in every detail,
we cannot be held responsible for any inaccuracies,
neither for any subsequent loss or damage arising.

Bibliographic information published by
Die Deutsche Bibliothek. Die Deutsche Bibliothek lists
this publication in the Deutsche Nationalbibliografie;
detailed bibliographic data is available in the Internet
at http://dnb.ddb.de.

Contents

Page

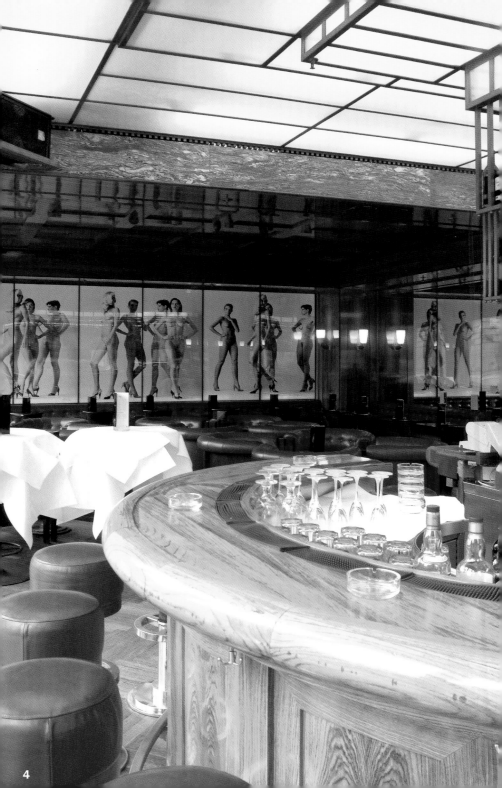

Einleitung

Kollwitzplatz, Gendarmenmarkt, Prenzlauer Berg, Szenen, Premieren, Boheme – eine Weltanschauung für sich. Was über Potsdamer Platz, Kulturbrauerei, Hackeschen Markt in wirklich jedem Stadtführer steht, signalisiert immer nur eines: Berlin, da muss man hin!
Berlin mausert sich zum Publikumsmagneten. Tendenz steigend! Ob das an den vielen guten Restaurants liegt, die in der einstigen kulinarischen Wüste an der Spree nun wie Pilze aus dem Boden schießen? Überall eröffnen neue Restaurants, Bars und Clubs, die sich an ein anspruchsvolles und designorientiertes Publikum richten. Gourmets setzen ebenso auf Berlin als Haute-Cuisine-Metropole. Wer die Genüsse der Stadt entdecken will, hat die Qual der Wahl – zwischen den etablierten Traditionsadressen wie dem Borchardt, Lutter & Wegner, VAU, Schwarzenraben und den Newcomern wie dem FELIX ClubRestaurant und The Room, die ihren Platz im Herzen der Stadt noch erobern werden.
Die Destinationen in Berlin – sie sind sehr oft die Erfüllung von Lebensträumen: Die BWLerin, der Opernsänger, der Meisterkoch, der Optiker, die Textilingenieurin fingen hier noch einmal ganz neu an. Mit Sack und Pack zogen sie hierher, weil sie Lebendigkeit und Bewegung suchten und Großstadt erleben wollten. Nun verwirklichen sie ihre eigenen Konzepte. Freilich, es gibt auch mehr Design als das pure Sein, sehr viel mehr Idioms als das eingeborene Berlinerisch, aber auch mehr kreative Kraft denn je.
Nicht nur unser Bundeskanzler und seine Minister, auch Persönlichkeiten aus Wirtschaft, Kunst und Kultur pflegen in der Bundeshauptstadt gerne zu speisen. Dies mag oft an der exklusiven Einrichtung und dem anspruchsvoll gestalteten Interieur liegen, zum anderen überzeugt die Küche oftmals mit regionalem und frankophilem Einschlag und, wie z.B. im GUY, mit einem in Deutschland einmaligen Angebot an 160 offenen Weinen. Kein Wunder, dass auch internationale Gäste wie Madeleine Albright, Henry Kissinger, George Clooney und Nicole Kidman immer wieder nach Berlin kommen. Längst ist die Stadt auch ein Synonym für die Welt des guten Geschmacks und bacchantischer Leidenschaft.

Joachim Fischer

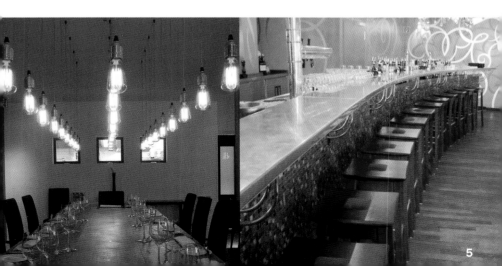

Introduction

Kollwitz Square, Gendarmenmarkt, Prenzlauer Berg, scenes, premieres, bohemian life—a philosophy in itself. Whatever is written in virtually every city guide about Potsdam Square, the Kulturbrauerei, and Hackescher Markt always implies the same thing: You've got to go to Berlin!
Berlin is quickly becoming a magnet for the public—and it's an upward trend. Might this be the result of the many good restaurants that have begun to spring up in the former culinary desert along the Spree River? Everywhere, new restaurants, bars, and clubs are opening that are targeted at a discerning and design-oriented public. Gourmets are also betting on Berlin as a capital of haute cuisine. Those interested in discovering the culinary delights of the city are faced with an abundance of choices—between the well-known, traditional establishments, such as Borchardt, Lutter & Wegner, VAU, Schwarzenraben, and newcomers like FELIX ClubRestaurant and The Room, all of which will inevitably capture a place in the heart of the city.
Destinations in Berlin often reflect the fulfillment of lifelong dreams: The business manager, the opera singer, the master chef, the optician, the textile engineer—these men and women have all made a fresh start here. They came here with bag and baggage in search of vitality, motion, and a taste of life in the big city. Now they are achieving their dreams. Of course, it's more about design than just pure existence, and more idioms abound than simply those of native Berliners, but there is also more creative force than ever.
Not only the Chancellor and his ministers enjoy dining in the nation's capital, but business, art, and cultural personalities do as well. This may be due to the exclusive furnishings and sophisticated interior design, or the cuisine itself, with its regional as well as Francophile accent and, as is the case at GUY, a selection of over 160 open wines that is unique in Germany. It is no wonder that international guests such as Madeleine Albright, Henry Kissinger, George Clooney and Nicole Kidman come back to Berlin time and again. The city has also long become a synonym for the world of good taste and bacchanalian passion.

Joachim Fischer

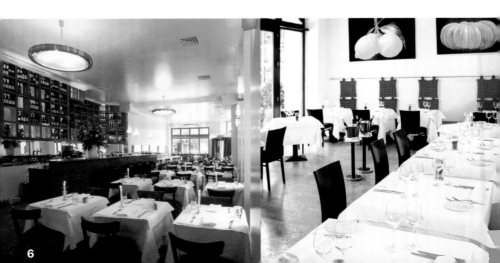

Introduction

Kollwitzplatz, Gendarmenmarkt, Prenzlauer Berg, les scènes, les premières, la bo-
hème – une vision du monde en soi. Tout ce qui se trouve vraiment dans chaque
guide touristique sur la Potsdamer Platz, la Kulturbrauerei, le Hackescher Markt
indique toujours la même chose : à Berlin, il faut y aller !
Berlin est en train de se transformer en attraction pour le public, et la tendance
augmente ! Cela est-il dû aux nombreux restaurants de bonne qualité qui pous-
sent maintenant du sol comme des champignons dans l'ancien désert culinaire
sur les bords de la Spree ? Partout ouvrent de nouveaux restaurants, bars et
clubs, qui s'adressent à un public exigeant et appréciant beaucoup le design. Les
gourmets misent également sur Berlin en tant que métropole de la haute cuisine.
Qui veut découvrir les plaisirs de la ville a l'embarras du choix – entre les adres-
ses traditionnelles établies comme les maisons Borchardt, Lutter & Wegner, VAU,
Schwarzenraben et les nouveautés comme FELIX ClubRestaurant et The Room qui
vont encore conquérir leur place au cœur de la ville.
Les destinations à Berlin sont souvent la réalisation de rêves de vie : la femme
économiste, le chanteur d'opéra, le cuisinier en maître, l'opticien, l'ingénieure en
textile y ont tout recommencé à zéro. Ils se sont installés ici avec leurs bagages,
parce qu'ils cherchaient de la vie et du mouvement, et voulaient vivre au contact
de la grande ville. Ils réalisent maintenant leurs propres concepts. Il y a aussi
bien sûr plus de design que l'essence à l'état pur et beaucoup plus d'idiomes que
le berlinois indigène, mais aussi plus de force créative que jamais.
Ce ne sont pas seulement notre chancelier et ses ministres qui se plaisent à aller
manger dans les restaurants de la capitale fédérale, mais aussi les personnalités
de l'économie, de l'art et de la culture. Ceci peut souvent être dû à l'aménage-
ment exclusif et à l'intérieur conçu de manière exigeante ; d'autre part, la cuisine
convainc souvent par une pointe régionale ainsi qu'une pointe francophile, et
comme par exemple au GUY dont l'offre inégalée en Allemagne présente 160 vins
ouverts. Il n'est donc pas étonnant que des invités internationaux tels que
Madeleine Albright, Henry Kissinger, George Clooney et Nicole Kidman reviennent
de temps à autres à Berlin. La ville est depuis longtemps un synonyme pour le
monde du bon goût et de la passion bacchanale.

Joachim Fischer

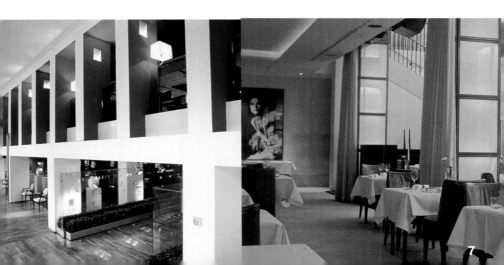

Introducción

Kollwitzplatz, Gendarmenmarkt, Prenzlauer Berg, ambientes, estrenos, bohemia –una visión del mundo muy propia. Lo que se dice en todas y cada una de las guías de turismo acerca de la Postdamer Platz, de la Kulturbrauerei, del Hackescher Markt siempre nos sugiere una cosa: ¡hay que ir a Berlín!

Berlín se transforma en una gran atracción ¡y la tendencia va en ascenso! La pregunta es si esto tiene que ver con la cantidad de buenos restaurantes que brotan como hongos en el otrora desierto culinario a orillas del Spree. Por todas partes se inauguran nuevos restaurantes, bares y clubs, destinados a un público exigente que se inclina hacia el buen diseño. Los gourmets también confían en Berlín como metrópoli de la haute cuisine. Quien quiera descubrir los placeres de la ciudad, tendrá dificultad para decidirse –entre los locales tradicionales como Borchardt, Lutter & Wegner, VAU, Schwarzenraben y los nuevos como FELIX Club-Restaurant y The Room, que están por conquistar su lugar en el corazón de la ciudad.

Los destinos finales en Berlín –a menudo son la realización de los sueños de la vida: la administradora de empresas, el cantante de ópera, el chef de cocina, el oculista, la ingeniera textil, emprendieron aquí un nuevo comienzo. Con todas sus pertenencias se mudaron aquí, porque buscaban vida y acción y querían descubrir la gran metrópoli. Ahora convierten en realidad sus propias ideas. Naturalmente, predomina el diseño sobre el puro ser, hay muchos más idiomas que el berlinés nativo, pero también hay más fuerza creativa que nunca.

No sólo el Canciller Federal y sus ministros, también personajes de la economía, el arte y la cultura suelen sentirse a gusto comiendo en la capital. Puede ser que por un lado esto se deba frecuentemente a la exclusividad de la decoración y del diseño interior; por el otro lado, a menudo la cocina convence con un toque regional y francófilo; y, por ejemplo, el GUY lo hace con una oferta excepcional en Alemania: una carta de 160 vinos abiertos. No es de extrañarse, entonces, que también huéspedes internacionales como Madeleine Albright, Henry Kissinger, George Clooney y Nicole Kidman vengan una y otra vez a Berlín. Hace ya tiempo que la ciudad es sinónimo de buen gusto y pasión báquica.

Joachim Fischer

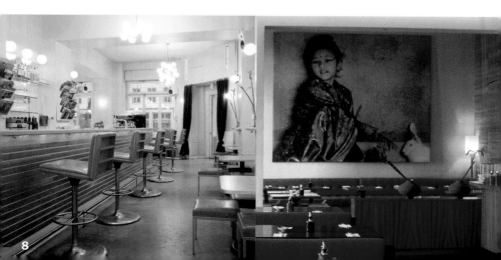

Introduzione

Kollwitzplatz, Gendarmenmarkt, Prenzlauer Berg, la scena, le prime, la bohème – una concezione del mondo di per sé. Qualunque cosa si trovi scritto in tutte le guide della città in merito al Potsdamer Platz, la Kulturbrauerei, il Hackescher Markt, il segnale è uno solo: a Berlino, bisogna assolutamente andarci!
Berlino sta diventando una attrazione per il pubblico. Con tendenza in rialzo! Saranno tutti quei buoni ristoranti che ormai nascono come i funghi da quello che una volta era un deserto culinario sul fiume Spree? Dappertutto aprono nuovi ristoranti, bar e club che si rivolgono ad un pubblico esigente ed amante del design. Anche i buongustai puntano su Berlino come metropoli della haute cuisine. Chi volesse scoprire le leccornie della città si trova di fronte ad una ampia scelta – tra i ristoranti di lunga tradizione come il Borchardt, il Lutter & Wegner, il VAU, lo Schwarzenraben ed i nuovi arrivati come il FELIX ClubRestaurant e The Room che ancora conquisteranno il loro posto nel cuore della città.
Destinazione Berlino: molto spesso rappresenta la realizzazione di un sogno di vita: la studentessa di Economia & Commercio, il cantante lirico, lo chef, l'ottico, l'ingegnera nel ramo tessile, tutti lì hanno ricominciato da capo. Si sono trasferiti con armi e bagagli perché cercavano la vivacità ed il movimento e perché volevano vivere la metropoli. Ora stanno realizzando i loro propri concetti. Certo, a volte c'è più design che il puro essere, ci sono molto più idiomi che l'originale dialetto berlinese, tuttavia c'è anche più forza creativa che mai.
Non solo il Cancelliere ed i suoi Ministri, ma anche personaggi importanti provenienti dall'economia, l'arte e la cultura amano mangiare nella Capitale. Ciò sarà spesso dovuto all'esclusività dell'arredamento ed alla raffinatezza della creazione degli interni, dall'altra parte è in molti casi la cucina a convincere con un tocco regionale e francofilo e, come ad esempio al GUY, con un'offerta di 160 vini sfusi, unica in Germania. Non stupisce quindi che anche clienti internazionali come Madeleine Allbright, Henry Kissinger, George Clooney e Nicole Kidman di frequente ritornano a Berlino. Da molto la città è diventata sinonimo per il mondo del buon gusto e della passione di bacco.

Joachim Fischer

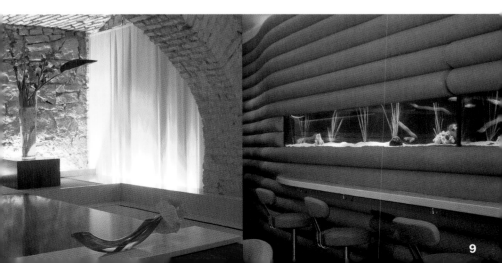

103 Bar

Design: Agentur 103

Kastanienallee 49 | Prenzlauer Berg
Phone: +49 30 48 49 26 51
Subway: Eberswalder Straße
Opening hours: Mon–Sun 10 pm to 3 am
Average price: € 10
Special features: Drinks only

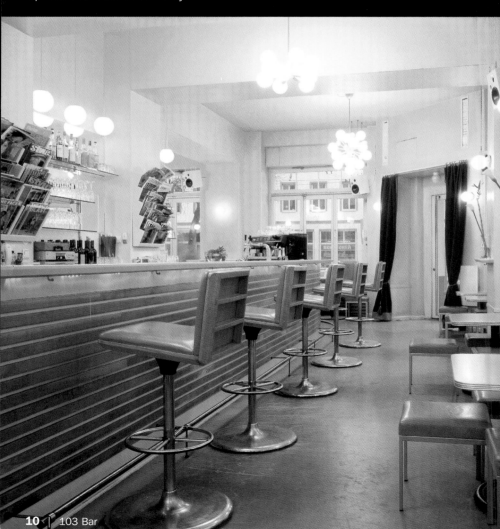

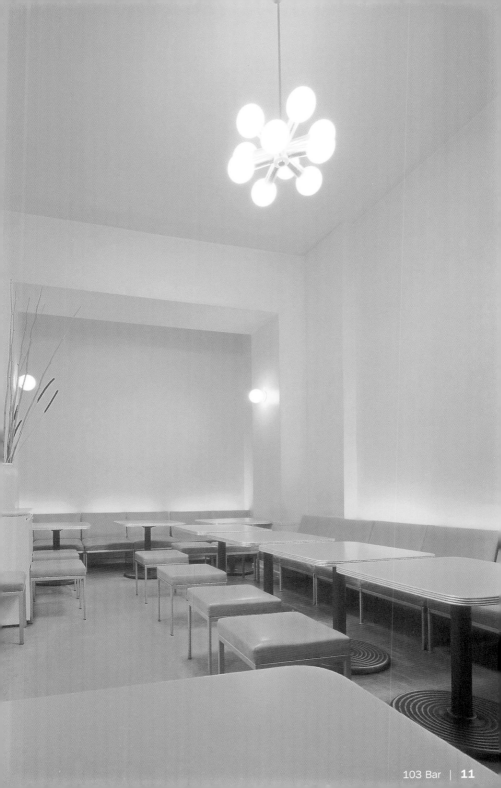

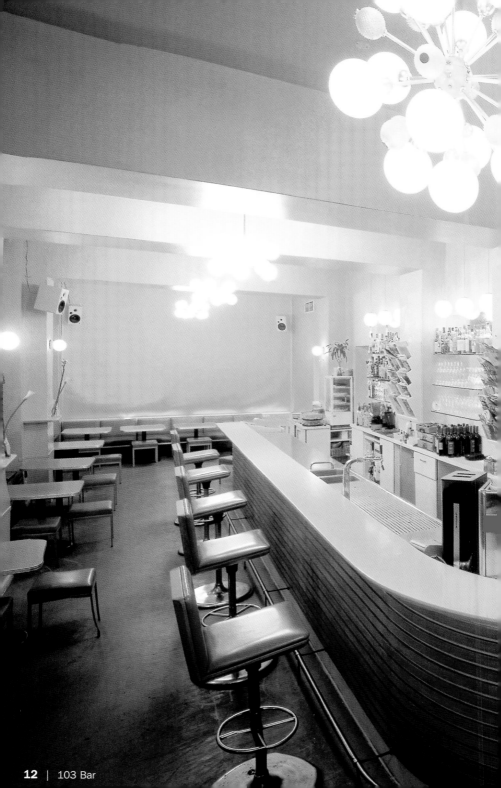

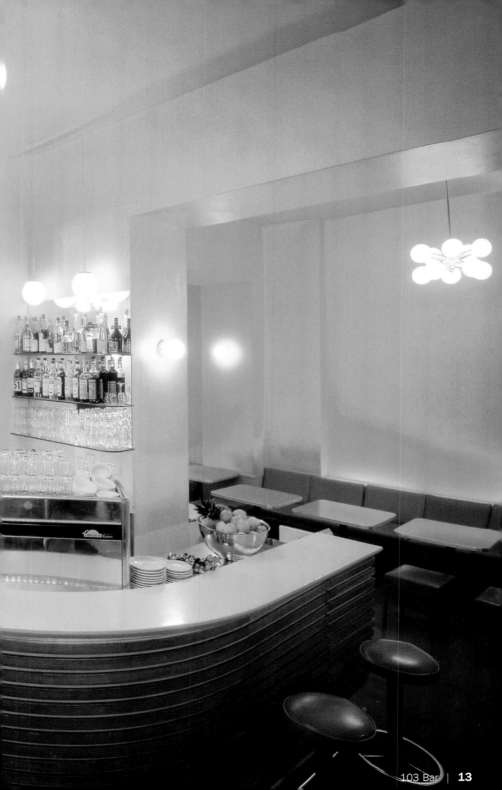

Phone: +49 30 54 71 05 90
Subway: Savignyplatz
Opening hours: Mon–Sat 12 noon to 1 am, Sunday 5:30 pm to 1 am
Average price: € 15
Reservation: Recommended
Cuisine: Italian

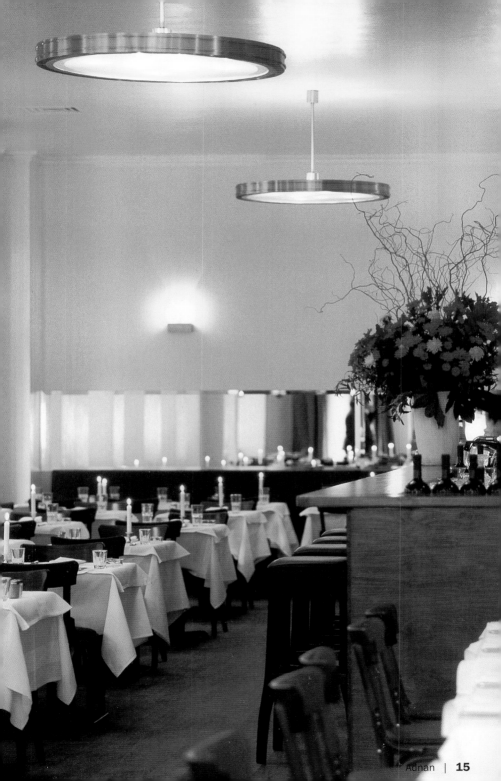

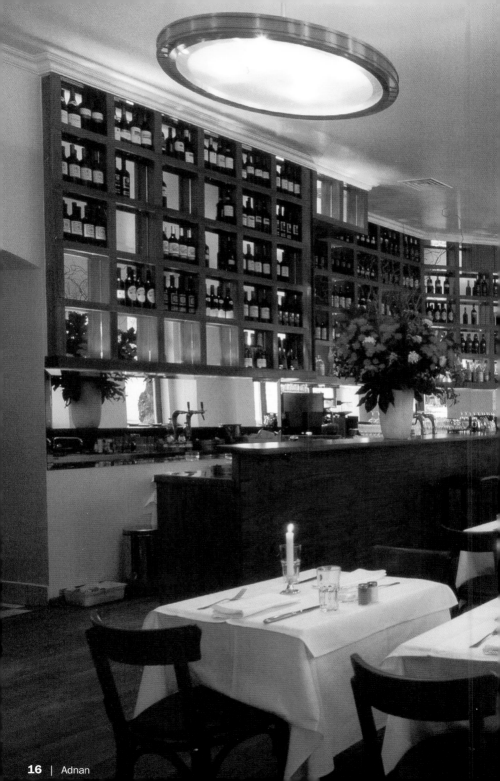

Al Dente

Design & Chef: Raffael Murtezani

Auguststraße 91 | Mitte
Phone: +49 30 28 39 10 55
Subway: Rosenthaler Platz
Opening hours: Every day 7 pm to 1 am
Average price: € 12
Reservation: Recommended
Cuisine: Italian

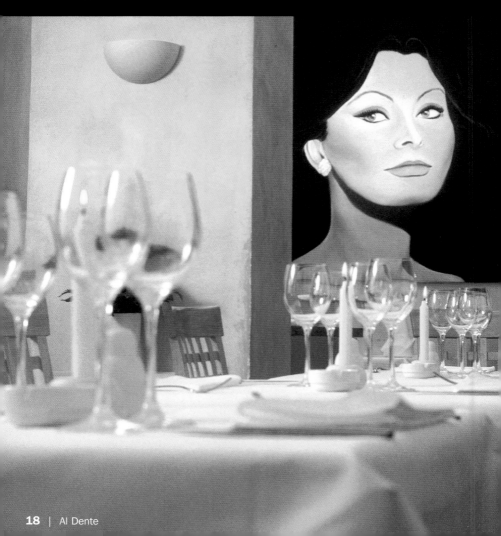

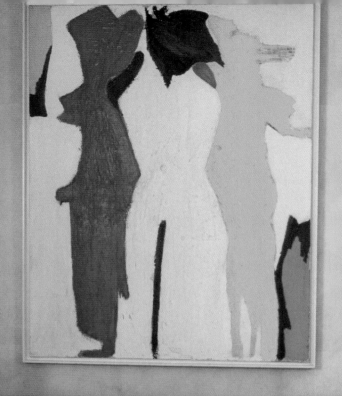
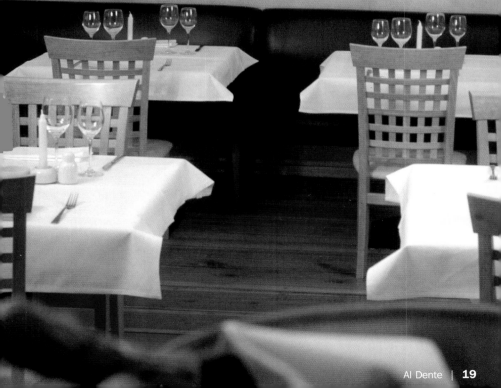

Bocca di Bacco

Design: Stefano Viviani | Chef: Alessandro Mannozzi

Friedrichstraße 167/168 | Mitte
Phone: +49 30 20 67 28 28
www.boccadibacco.de | info@boccadibacco.de
Subway: Friedrichstraße
Opening hours: Mon–Sat 12 noon to 12 midnight, Sun 6 pm to 12 midnight
Average price: € 22
Reservation: Recommended
Cuisine: Italian | Gault Millau prized

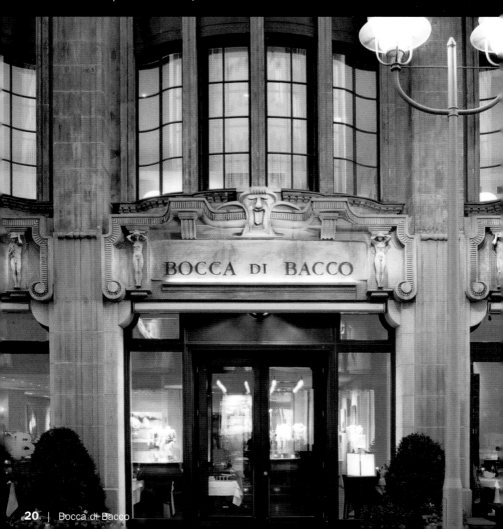

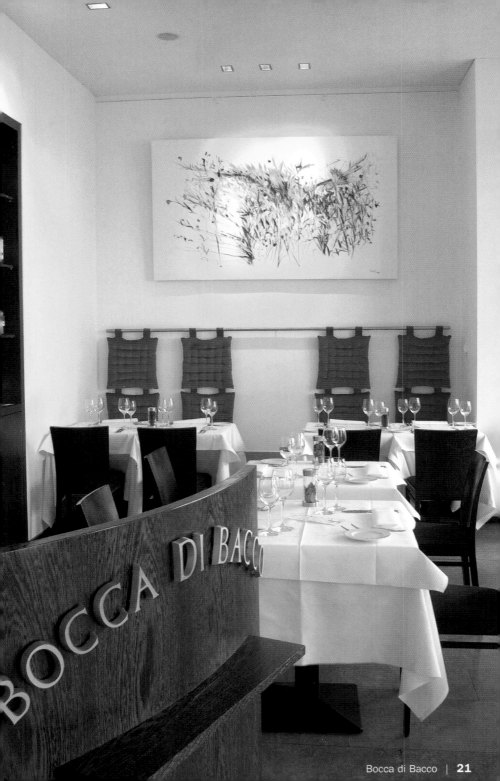

Schwertfischfilet

in Panade aus getrockneten Tomaten auf Tintenfisch-Gemüse-Bouquet

Swordfish Filet in a Dried Tomato Coating on a Bouquet of Squid and Vegetables

Filet d'espadon et sa panure de tomates séchées sur bouquet de légumes à la pieuvre

Filete de pez espada rebozado con tomates secos sobre un bouquet de verduras y calamar

Filetto di pesce spada con impanatura di pomodori secchi sul letto di seppia e verdura

600 g Schwertfisch
1 Karotte, 1 Zucchini, 1 Kartoffel
150 g Tintenfisch
1 kleine weiße Zwiebel
0,1 l Weißwein
3 EL Olivenöl
1 Knoblauchzehe, Petersilie

Für die Panade:
200 g geriebene Semmel
70 g getrocknete Tomaten in Olivenöl
10 g Schnittlauch, 10 g Salbei, 10 g Basilikum,
10 g Petersilie
1 Knoblauchzehe
1 EL Olivenöl

Die getrockneten Tomaten vom Öl, in das sie eingelegt waren, gut abtropfen lassen. Zusammen mit den Kräutern und etwas Olivenöl im Mixer verrühren, langsam die Hälfte der geriebenen Semmel dazugeben, bis sich eine teigartige Masse gebildet hat. Zur Masse die restliche geriebene Semmel hinzugeben und mit der Hand so lange vermengen, bis sich eine krümelige Panade gebildet hat.
Die Zwiebel in längliche Stücke schneiden und in etwas Olivenöl kurz glasig anbraten. Die Zucchini, Kartoffel und Karotte in Julienne schneiden und blanchieren. Nun den Tintenfisch in dünne, längliche Streifen schneiden und zusammen mit dem blanchierten Gemüse, der gehackten Petersilie und dem Knoblauch zu den Zwiebeln in die Pfanne geben, mit Weißwein ablöschen und zwei bis drei Minuten fertig kochen.
Den Schwertfisch beidseitig dezent salzen und pfeffern, mit etwas Olivenöl antupfen und durch die Panade ziehen. Den panierten Fisch im vorgeheizten Ofen ca. acht Minuten bei 180 °C backen. Er sollte bissfest, saftig, jedoch durchgebacken sein.

1 lb 5 oz swordfish
1 carrot, 1 zucchini, 1 potato
5–5½ oz squid
1 small white onion
0,1 l white wine
3 tbsp olive oil
1 garlic clove, parsley

Coating:
7 oz breadcrumbs
2½ oz sun-dried tomatoes in olive oil
⅓ oz chives, ⅓ oz sage, ⅓ oz basil,
⅓ oz parsley
1 garlic clove
1 tbsp olive oil

Allow any oil on the dried tomatoes to drip off. Blend with herbs and some olive oil in a blender. Slowly add about the half of the breadcrumbs, until it has a batter-like consistency. Add the rest of the breadcrumbs to the batter by hand until a crumby batter results.
Slice onion into long strips and sauté briefly in some olive oil until golden. Slice the zucchini, potato, and carrot into long, thin strips and blanch. Cut the squid into long strips and add to the onion pan along with the blanched vegetables, chopped parsley and garlic. Add the white wine and cook for two to three minutes.
Salt and pepper the swordfish modestly, blot with olive oil and dip into batter. Bake breaded fish for about eight minutes at 350 °F. The fish should be firm, juicy, yet cooked through.

600 g d'espadon
1 carotte, 1 courgette, 1 pomme de terre
150 g de pieuvre
1 petit oignon blanc
0,1 l de vin blanc
3 c. à soupe d'huile d'olive
1 gousse d'ail, persil

Pour la panure:
200 g de chapelure
70 g de tomates séchées dans huile d'olive
10 g de ciboulette, 10 g de sauge,
10 g de basilic, 10 g de persil
1 gousse d'ail
1 c. à soupe d'huile d'olive

Bien égoutter les tomates séchées de l'huile dans laquelle elles ont été baignées. Mélanger avec les fines herbes et un peu d'huile d'olive dans le mixeur, ajouter doucement la chapelure par moitié environ jusqu'à formation d'une masse pâteuse. Ajouter à la masse la chapelure restante et pétrir à la main jusqu'à obtention d'une panure grumeleuse.

Couper l'oignon en julienne et faire revenir à l'huile d'olive. Couper la courgette, la pomme de terre et la carotte en lames fines et blanchir. Couper maintenant la pieuvre en longues lames fines et ajouter aux oignons dans la poêle avec les légumes blanchis, le persil haché et l'ail, arroser avec le vin blanc et faire cuire encore durant deux à trois minutes.

Saler et poivrer l'espadon convenablement des deux côtés, badigeonner à l'huile d'olive et rouler dans la panure. Faire cuire le poisson pané dans le four préchauffé durant environ huit minutes à 180 °C. Celui-ci doit être ferme, juteux, mais cuit à point.

600 g de pez espada
1 zanahoria, 1 calabacín, 1 patata
150 g de calamares
1 cebolla blanca pequeña
0,1 l de vino blanco
3 cucharadas de aceite de oliva
1 diente de ajo, perejil

Para el rebozado:
200 g de pan rallado
70 g de tomates secos en aceite de olivo
10 g de cebollino, 10 g de salvia,
10 g de albahaca, 10 g de perejil
1 diente de ajo
1 cucharada de aceite de oliva

Escurrir muy bien el aceite de conserva de los tomates secos. Mezclarlos en la batidora con las hierbas y un poco de aceite de oliva, agregar lentamente la mitad del pan rallado hasta que se forme una masa. A la masa agregarle el resto de las migas de pan y mezclar con la mano hasta obtener un rebozado con suficiente miga.

Cortar la cebolla en trozos a lo largo y sofreirla en aceite. Cortar el calabacín, la patata y la zanahoria en tiras largas y finas y escaldarlas. Cortar el calamar en tiras largas y finas y junto con las verduras escaldadas, el perejil picado y el ajo, agregarlo a la cebolla en la sartén, reducir con el vino blanco y cocer durante dos o tres minutos.

Salpimentar ligeramente el pez espada por ambos lados, ponerle unas gotitas de aceite de oliva y pasarlo por el rebozado. Ponerlo en el horno precalentado unos ocho minutos, a 180 °C. Debe quedar a punto, jugoso, pero bien hecho.

600 g di pesce spada
1 carota, 1 zucchino, 1 patata
150 g di seppia
1 piccola cipolla bianca
0,1 l di vino bianco
3 cucchiai di olio d'oliva
1 spicchio di aglio, prezzemolo

Per l'impanatura:
200 g di pangrattato
70 g di pomodori secchi in olio d'oliva
10 g di erba cipollina, 10 g di salvia,
10 g di basilico, 10 g di prezzemolo
1 spicchio di aglio
1 cucchiaio di olio d'oliva

Fate sgocciolare bene i pomodori secchi dall'olio in cui erano conservati. Frullateli nel mixer insieme alle erbe e con poco olio d'oliva, aggiungete poco alla volta la metà di pangrattato fino ad ottenere la consistenza di un impasto. Aggiungete il rimanente pangrattato all'impasto e mescolate a mano fino ad ottenere una impanatura sbriciolata.

Tagliate le cipolle in pezzi allungati e fateli appassire brevemente con poco olio d'oliva. Tagliate lo zucchino, la patata e la carota in strisce sottili ed allungate e scottatele brevemente. Ora tagliate la seppia in strisce sottili ed allungate e aggiungetela alla cipolla in padella, insieme alla verdura scottata, il prezzemolo tritato e l'aglio, spruzzate il tutto con vino bianco e finite la cottura per due a tre minuti.

Salate e pepate il pesce spada delicatamente da entrambi i lati, picchiettatelo con poco olio d'oliva e passatelo attraverso l'impanatura. Mettete il pesce impanato nel forno preriscaldato, per circa otto minuti a 180 °C. Il pesce dovrebbe risultare ben cotto al dente, ma anche succoso.

Design: Rainer Müller Architekt
Chef: Philippe Lemoine

Französische Straße 47 | Mitte
Phone: +49 30 81 88 62 50
www.gastart.de (Catering) | borchardt@gastart.de
Subway: Französische Straße
Opening hours: Every day 11:30 am to 1 am
Average price: € 15–20
Reservation: Recommended
Cuisine: French

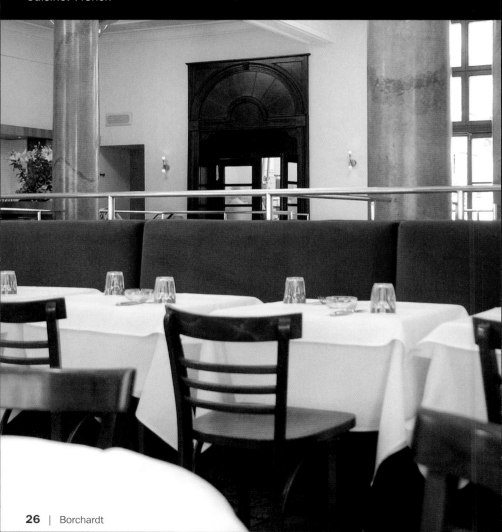

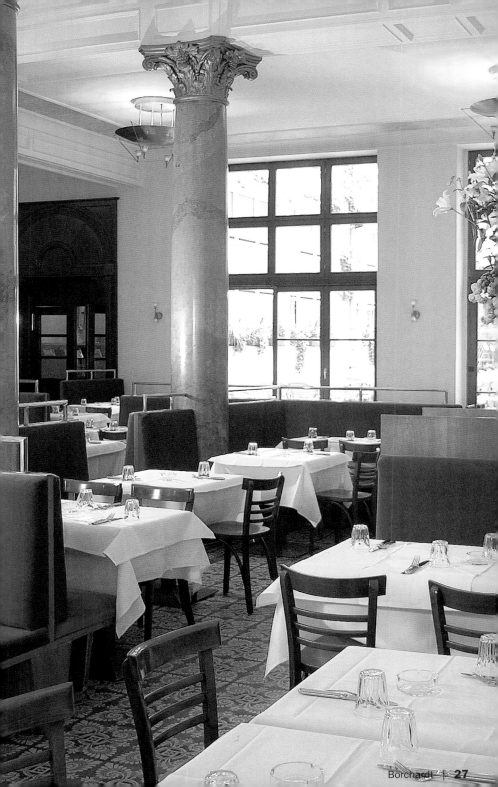

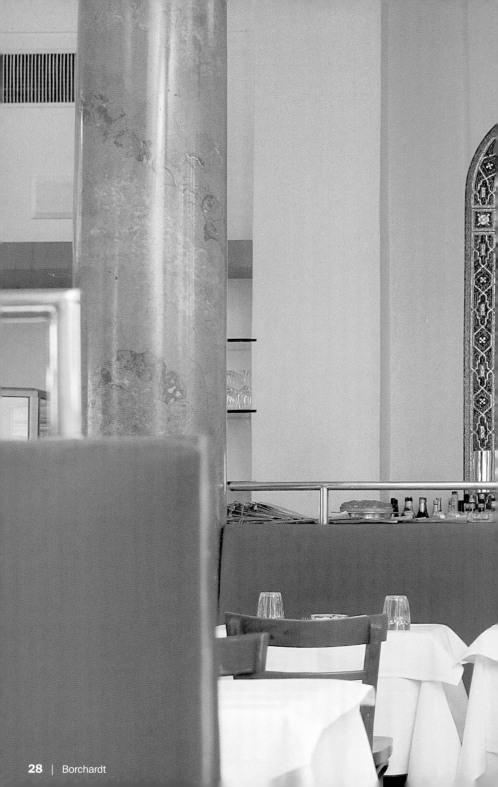

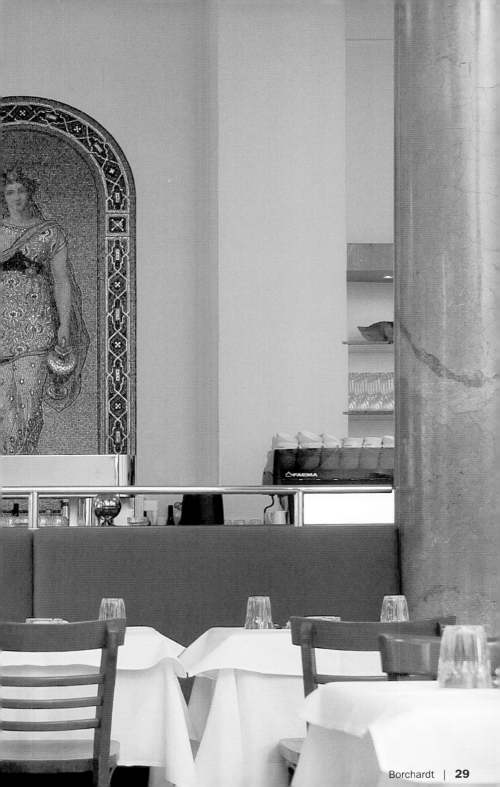

Wiener Schnitzel
mit Kartoffelsalat

Wiener Schnitzel with Potato Salad

Escalope à la viennoise et sa salade de pommes de terre

Escalope a la vienesa con ensalada de patatas

Costolette alla viennese con insalata di patate

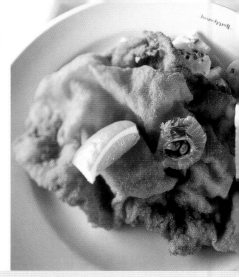

4 Schnitzel aus der Kalbskeule von je 180 g
4 EL Mehl
2 verquirlte Eier
4 EL Semmelbrösel (vom Bäcker)
Salz, frisch gemahlener Pfeffer
300 g Butterschmalz zum Ausbacken
Für die Garnitur:
4 Sardellenfilets, 8 Kapern, 4 Kerbelblättchen, 1 Zitrone, in Spalten geschnitten

600 g fest kochende Kartoffeln
4 EL Apfelessig
3 TL mittelscharfer Senf
80 ml Sonnenblumenöl
200 ml Rinderbrühe
3 fein gewürfelte Schalotten
4 EL gebratene Räucherspeckwürfel
Je 1 EL fein geschnittene Petersilie und Liebstöckel
Salz, frisch gemahlener schwarzer Pfeffer

Kartoffeln in der Schale kochen und noch heiß pellen. In Scheiben schneiden und noch warm in einer Marinade aus Apfelessig, Senf, Sonnenblumenöl, Brühe, Schalottenwürfeln, Salz und Pfeffer wenden. Zuletzt den ausgelassenen Speck und die Kräuter unterheben. Den Kartoffelsalat mindestens sechs Stunden durchziehen lassen und vor dem Servieren vorsichtig erwärmen.
Die Schnitzel flach klopfen. Mit Salz und Pfeffer würzen, anschließend zuerst in Mehl, dann in verquirltem Ei und in den Semmelbrösel locker wenden. Die Brösel dabei nicht andrücken, sonst souffliert die Panade beim Ausbacken nicht. In einer Pfanne mit hohem Rand das Butterschmalz über mittlerer Flamme erhitzen. Nacheinander die Schnitzel im Fett schwimmend ausbacken, bis sie sich wellen und eine goldbraune Kruste haben. Schnitzel herausheben und auf Küchenpapier entfetten.

4 veal cutlets of 6 – 6$^{1}/_{2}$ oz each
4 tbsp flour
2 whisked eggs
4 tbsp breadcrumbs (baker's quality)
Salt, freshly ground pepper
$^{1}/_{2}$ lb 3 oz clarified butter for frying
For garnish:
4 anchovy filets, 8 capers, 4 chervil leaves, 1 lemon, cut into wedges

1 lb 5 oz firm-cooking potatoes
4 tbsp apple vinegar
3 tsp medium-hot mustard
80 ml sunflower oil
310 ml beef broth
3 finely diced shallots
4 tbsp sautéed smoked ham cubes
1 tbsp each chopped parsley and lovage
Salt, freshly ground black pepper

Boil potatoes in their skins and peel while hot. Slice, and stir in marinade of apple vinegar, mustard, sunflower oil, broth, diced shallots, salt and pepper while still warm. Then fold in sautéed ham and herbs. Allow the potato salad to marinate for at least six hours. Heat gently before serving.
Tenderize the cutlets. Salt and pepper them, then turn in flour. Then gently turn in whisked eggs and breadcrumbs. Do not press the breadcrumbs into the meat; otherwise the batter will not puff when fried. Heat the clarified butter in a high pan over medium heat. Fry the cutlets one at a time in the butter until they ripple and a golden crust forms. Remove cutlets from pan and blot on paper towels.

4 escalopes de veau tirées de la cuisse et de
180 g chacune
4 c. à soupe de farine
2 œufs battus
4 c. à soupe de chapelure (du boulanger)
Sel, poivre fraîchement moulu
300 g de beurre fondu
Pour la garniture:
4 filets d'anchois, 8 câpres, 4 petites feuilles de
cerfeuil, 1 citron, coupé en lamelles

600 g de pommes de terre fermes
4 c. à soupe de vinaigre de cidre
3 c. à café de moutarde douce
80 ml d'huile de tournesol
200 ml de bouillon de bœuf
3 échalotes en dés fins
4 c. à soupe de lardons fumés en dés poêlés
Respectivement 1 c. à soupe de persil et de
livèche coupées finement
Sel, poivre noir fraîchement moulu

Faire cuire les pommes de terre en robe des
champs et les peler encore très chaudes. Couper
en tranches et les baigner encore chaudes dans
une marinade de vinaigre de cidre, de moutarde,
d'huile de tournesol, de bouillon, de dés d'écha-
lote, de sel et de poivre. Y ajouter enfin les lar-
dons restants et les fines herbes. Laisser reposer
la salade de pommes de terre au moins six heu-
res et réchauffer prudemment avant de servir.
Attendrir les escalopes pour les aplatir. Assaison-
ner avec du sel et du poivre et faire rouler dans la
farine. Baigner ensuite dans l'oeuf battu et faire
rouler de manière souple dans la chapelure. Ne
pas appuyer sur la chapelure, sinon la panure ne
souffle pas durant la cuisson. Faire chauffer le
saindoux à feu moyen dans une poêle à bords
élevés. Faire cuire l'une après l'autre les escalo-
pes flottant dans la graisse, jusqu'à ce qu'elles
ondulent et donnent une croûte bien dorée.
Retirer les escalopes et les dégraisser à l'essuie-
tout.

4 escalopes de pernil de ternera, de 180 g cada
uno
4 cucharadas de harina
2 huevos batidos
4 cucharadas de pan rallado (de panadería)
Sal, pimienta recién molida
300 g de grasa de mantequilla para cocinar
Para la guarnición:
4 anchoas, 8 alcaparras, 4 hojitas de perifollo,
1 limón cortado en gajos

600 g de patatas (no harinosas)
4 cucharadas de vinagre de manzana
3 cucharaditas de mostaza semipicante
80 ml de aceite de girasol
200 ml de caldo de carne
3 chalotas picadas finamente
4 cucharadas de tocino ahumado en cubitos, frito.
1 cucharada de perejil finamente picado y una de
levística
Sal y pimienta negra recién molida

Cocer las patatas con piel y pelarlas aún calien-
tes. Cortarlas en rodajas y ponerlas así calientes
en una marinada de vinagre de manzana, mosta-
za, aceite de girasol, caldo, cubitos de chalota,
sal y pimienta. Por último, agregar el tocino y las
hierbas. Dejar reposar mínimo seis horas y antes
de servir calentar con cuidado.
Los escalopes aplanarlos con un mazo. Condi-
mentarlos con sal y pimienta y pasarlos por hari-
na. A continuación pasarlos por los huevos bati-
dos y el pan rallado. Al hacerlo no presionar la
ralladura de pan, de lo contrario no se inflará el
rebozado al freir. En una sartén profunda calentar
a fuego medio la grasa de mantequilla. Colocar
los escalopes en suficiente grasa, de forma que
floten, y freírlos hasta que se ondulen y queden
crujientes y dorados. Sacarlos y escurrirlos sobre
papel de cocina.

4 fette di coscia di vitello di 180 g cadauna
4 cucchiai di farina
2 uova sbattute
4 cucchiai di farina di pangrattato (dal panettiere)
Sale, pepe macinato al momento
300 g di grasso puro di burro per la frittura in
padella
Per la guarnizione:
4 filetti di acciughe, 8 capperi, 4 foglioline di
cerfoglio, 1 limone tagliato a spicchi

600 g di patate dalla consistenza solida
4 cucchiai di aceto di mele
3 cucchiaini di senape di media intensità di sapore
80 ml di olio di semi di girasole
200 ml di brodo di manzo
3 scalogne tagliate finemente a dadi
4 cucchiai di dadi arrostiti di pancetta affumicata
1 cucchiaio di prezzemolo tagliato finemente ed
1 di levistico
Sale, pepe nero macinato al momento

Fate bollire le patate con la loro buccia e sbuccia-
tele ancora calde. Affettatele e rigiratele, ancora
tiepide, nella marinata composta da aceto di
mele, senape, olio di semi di girasole, brodo, sca-
logne a dadi, sale e pepe. In fondo mescolate con
delicatezza la pancetta di cui la parte grassa si
sarà sciolta e le erbe. Fate marinare l'insalata di
patate per almeno sei ore e riscaldatela con cau-
tela prima di servirla.
Battete le fese di vitello con il batticarne. Salate
e pepatele e giratele nella farina. Successiva-
mente giratele nelle uova sbattute e passatele nel
pangrattato. Non schiacciatele nel pangrattato,
altrimenti l'impanatura non si gonfierà durante la
cottura. In una padella dal bordo alto scaldate il
grasso puro di burro a fuoco medio. Fate friggere
le fese una dopo l'altra in abbondante grasso
puro di burro fino ad ottenere l'effetto onda ed un
colore ben dorato dell'impanatura. Togliete le fese
dalla padella e scolatele dal grasso di cottura,
appoggiandole sulla carta da cucina assorbente.

Café de France

Design: Philippe Starck, Yves Taralon | Chef: Alain Gauvrit

Unter den Linden 62–68 | Mitte
Phone: +49 30 20 64 13 91
www.peugeot-avenue.de | info@peugeot-avenue.de
Subway: Brandenburger Tor
Opening hours: Mon–Sat 10 am to 10 pm, Sun 10 am to 6 pm
Average price: € 12
Reservation: Recommended
Cuisine: French

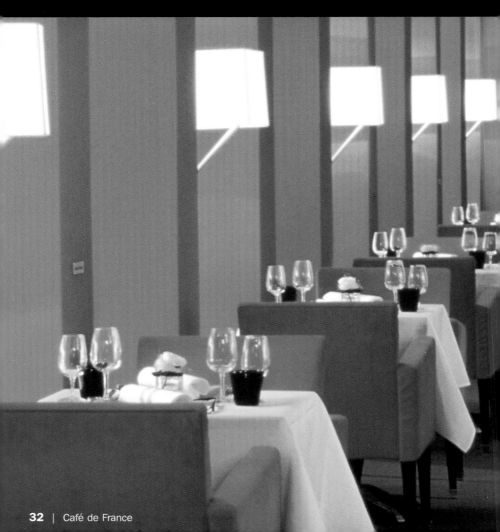

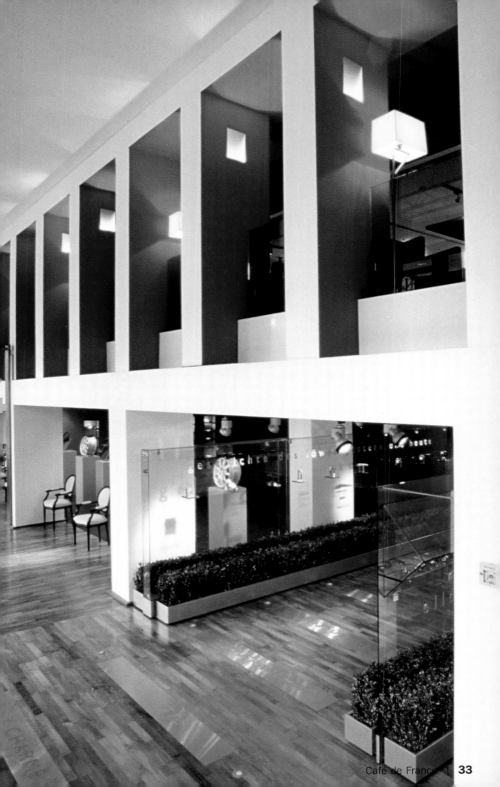

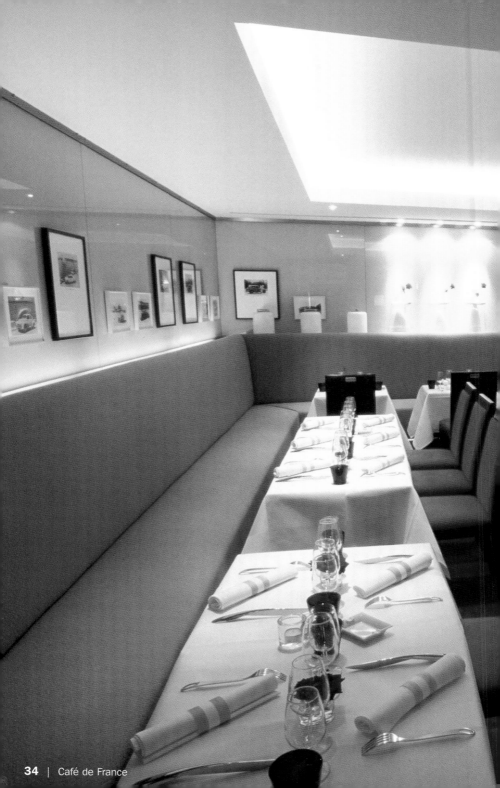

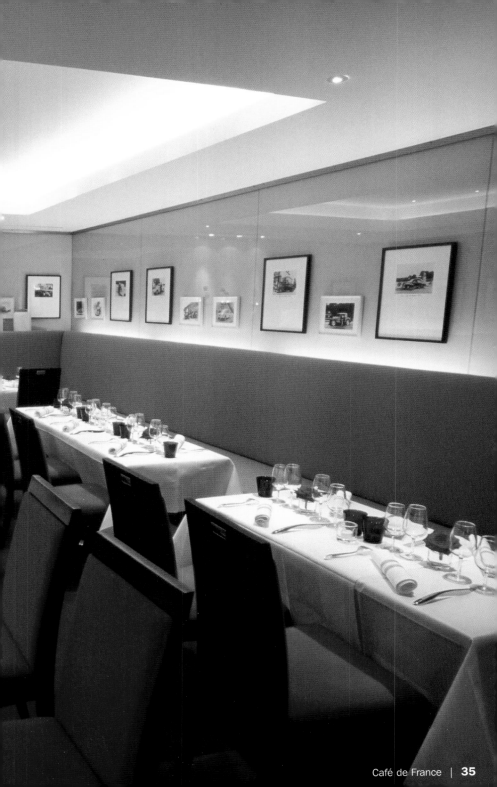

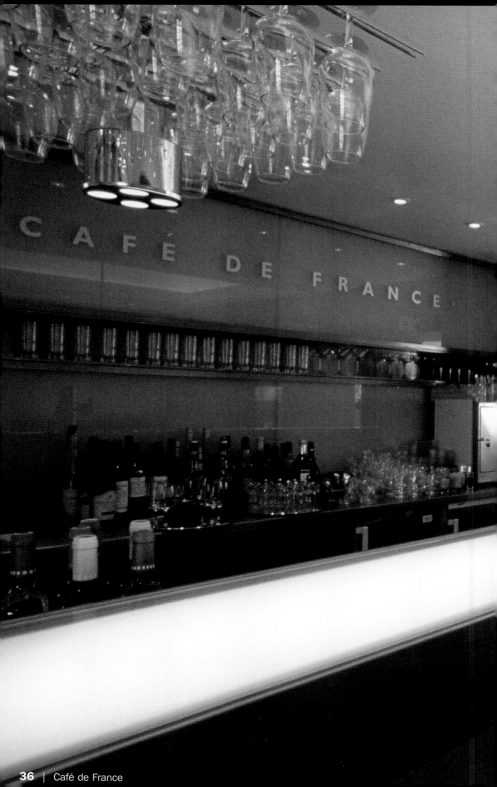

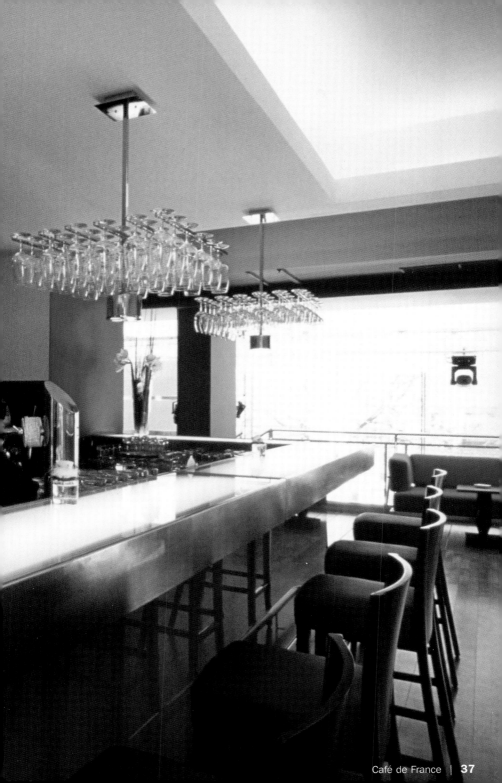

Caroshi Bar & Lounge

Design: Markus Diebel, Richard Rogers, Renzo Piano
Chef: Mario, Bernard Halej

Linkstraße 4 | Mitte / Tiergarten
Phone: +49 30 25 29 33 52
www.caroshi.info | team@caroshi.info
Subway: Potsdamer Platz
Opening hours: Mon–Fri 10 am to open end, Sat–Sun 12 noon to open end,
Happy hour Sun–Fri 5 to 8 pm
Average price: € 7
Special features: Business lunch and finger food until 6 pm, sushi after 6 pm,
available for private events, Wed–Sat live DJs

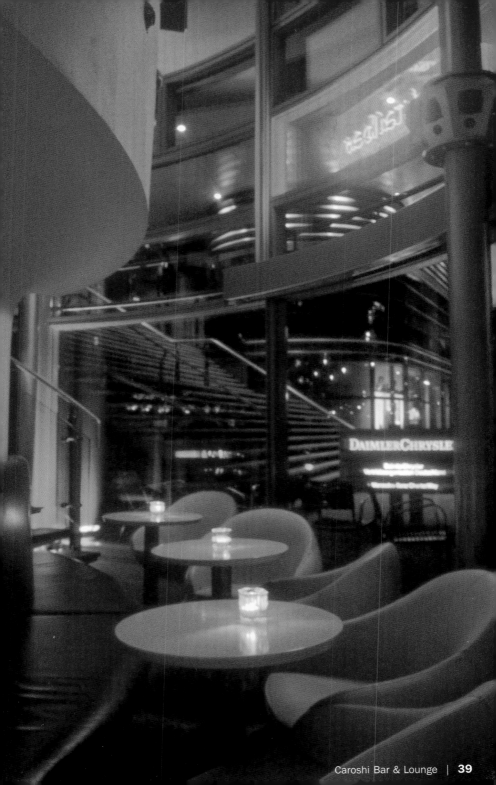

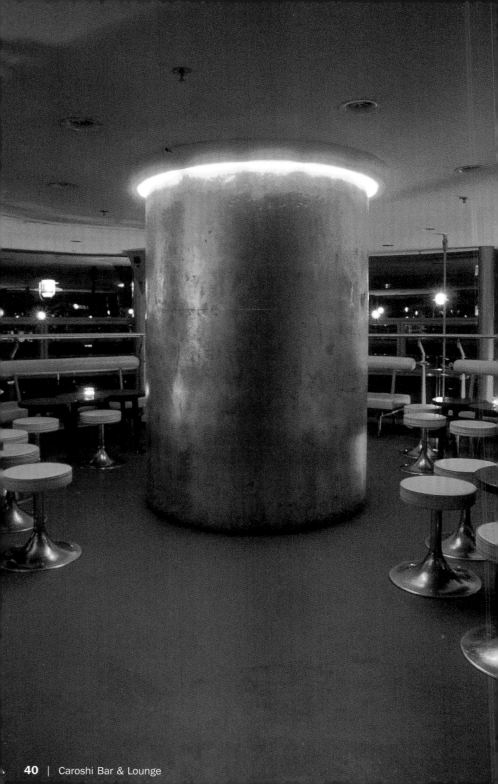

FACIL Restaurant

Design: Ralph Flum | Chef: Michael Kempf

Potsdamer Straße 3 | Tiergarten
Phone: +49 30 5 90 05 12 34
www.facil.de | welcome@facil.de
Subway: Potsdamer Platz
Opening hours: Mon–Fri Lunch 12 noon to 3 pm, Dinner 7 pm to 1 am
Average price: € 25
Reservation: Recommended
Cuisine: Mediterranean, classical pure | Michelin & Gault Millau prized

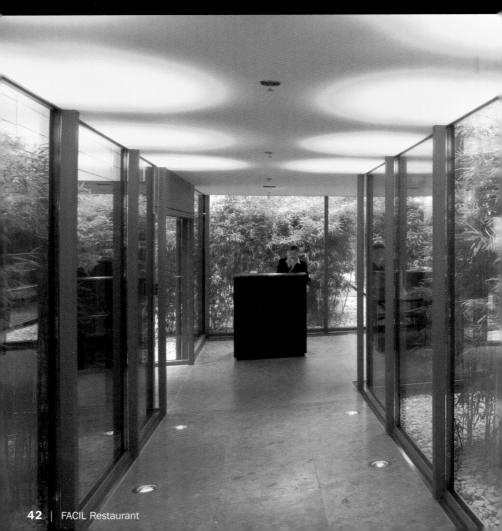

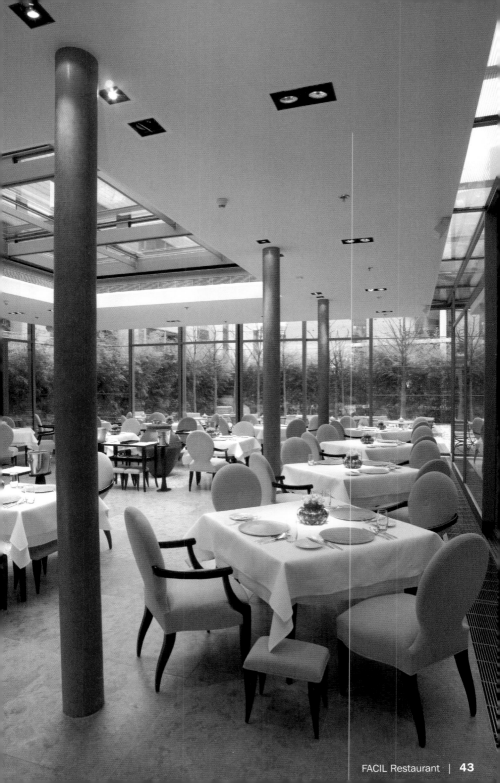

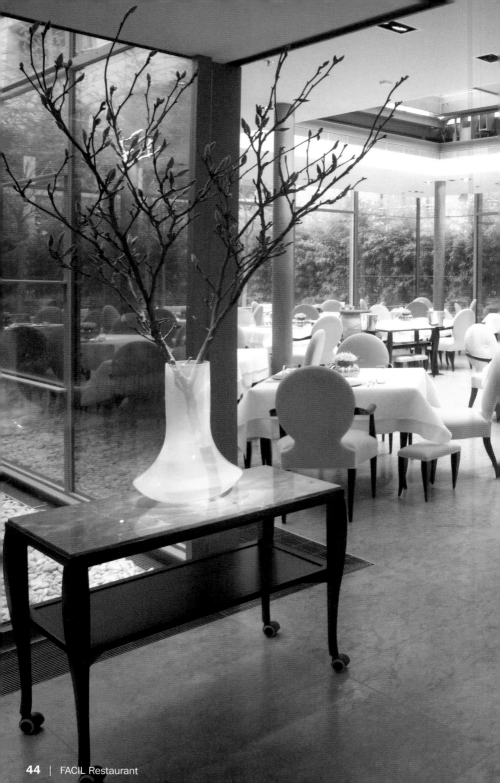

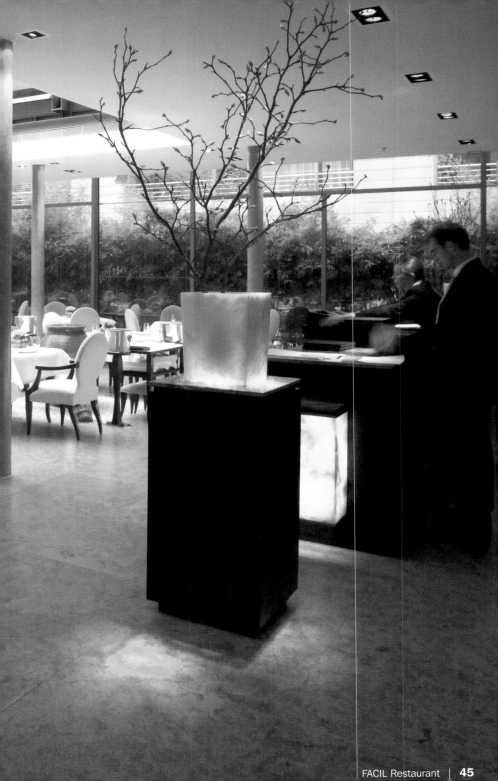

Gänseleberterrine

mit gegrilltem Spargel,
Taubenbrust und Mispeln

Terrine of Goose Liver and Grilled Asparagus, Squab Breast and Medlars

Terrine de foie d'oie avec asperges grillées, poitrine de pigeon et nèfles

Terrina de hígado de oca con espárragos a la brasa, pechuga de paloma y nísperos

Terrina di fegato d'oca con asparagi gri gliati, petto di piccione e nespole

250 g Gänseleber, geputzt
50 ml weißen Portwein, auf die Hälfte eingekocht
1 g Meersalz
2 g Pökelsalz
3 g Puderzucker
1 Spritzer Cognac
300 g weißen Spargel, geschält
100 g wilden Spargel
Meersalz, Zitrone, braunen Zucker
250 g Mispeln
80 g brauner Zucker
100 ml Orangensaft
1/2 Vanilleschote
2 Taubenbrüste
Meersalz, Pfeffer

Gänseleber mit den Gewürzen und dem Alkohol 48 Stunden marinieren.
In eine mit Folie ausgelegte Terrinenform pressen und im Backofen bei 50 °C 40 Minuten garen. Kühlstellen und stürzen. In vier Scheiben schnei-den und quadratisch ausstechen. Kühl stellen.
Spargel mit den Gewürzen al dente garen und kurz abschrecken. Halbieren, trockentupfen und mit etwas Öl kräftig angrillen.
Mispeln schälen und achteln. Zucker karamellisieren, mit Orangensaft ablöschen und mit der Vanilleschote einkochen. Mispeln dazugeben und weich schmoren.
Taubenbrüste würzen, Hautseiten kross anbraten und bei 180 °C drei Minuten in den Ofen schieben, herausnehmen und zwei Minuten ruhen lassen.
Gegrillten Spargel längs auf die Teller legen und die Terrine obendrauf setzen.
Die Mispelschnitze verteilen und den Spargel mit dem Mispelfond nappieren. Taubenbrüste mit einem scharfen Messer dünn aufschneiden und auf die Teller verteilen.

8 oz goose liver, cleaned
50 ml white port wine, boiled down to half its volume
Pinch of sea salt
1/4 tsp pickling salt
1 tsp powdered sugar
Dash Cognac
1/2 lb 3 oz white asparagus, peeled
3 1/2 oz wild asparagus
Sea salt, lemon, brown sugar
9 oz medlars
3 oz brown sugar
100 ml orange juice
1/2 vanilla pod
2 squab breasts
Sea salt, pepper

Marinate the goose liver with the spices and the alcohol for 48 hours.
Line a terrine with aluminum foil and press goose liver into it. Bake at 120 °F for 40 minutes. Chill, then turn over to remove from terrine. Cut into four slices and cut out square-shaped pieces. Chill.
Cook asparagus with the spices until al dente and rinse briefly in cold water. Cut in half, blot dry, and grill vigorously in a bit of oil.
Peel medlars and cut into eighths. Caramelize sugar, add orange juice and boil down with vanilla bean. Add medlars and stew until soft.
Salt and pepper the squab breasts, sauté until crispy and bake for three minutes in a 350 °F oven. Take out and allow to rest for two minutes. Place grilled asparagus lengthwise on plate and the terrine on top.
Distribute the medlars pieces and brush asparagus with remaining loquat stock. Slice squab breast thinly with a sharp knife and distribute on plates.

250 g de foie d'oie, lavé
50 ml de porto blanc, chauffé pour moitié
1 g de sel marin
2 g de sel de salaison
3 g de sucre en poudre
1 goutte de cognac
300 g d'asperges blanches, épluchées
100 g d'asperges sauvages
Sel marin, citron, sucre roux
250 g de nèfles
80 g de sucre roux
100 ml de jus d'orange
1/2 gousse de vanille
2 poitrines de pigeon
Sel marin, poivre

Faire macérer le foie d'oie dans les épices et l'alcool pendant 48 heures.
Entasser dans un moule à terrine (recouvert auparavant d'une feuille de cuisson) et faire cuire au four à 50 °C pendant 40 minutes Faire refroidir et démouler. Couper en quatre tranches et couper en forme carrée. Mettre à refroidir.
Cuire les asperges avec les épices al dente et tremper dans l'eau froide. Couper en deux, tamponner pour faire sécher et faire griller avec de l'huile.
Eplucher les nèfles et couper en huit. Faire caraméliser le sucre, arroser au jus d'orange et cuire avec la gousse de vanille. Ajouter les nèfles et braiser pour ramollir.
Assaisonner les poitrines, faire rôtir la peau jusqu'à ce que celle-ci soit croustillante, faire cuire trois minutes à 180 °C dans le four, retirer et laisser reposer deux minutes.
Déposer les asperges grillées transversalement sur l'assiette et y poser la terrine.
Répartir les copeaux de nèfles et napper les asperges avec le fond de nèfles. Découper finement la poitrine de pigeon avec un couteau tranchant et répandre sur les assiettes.

250 g de hígado de oca, limpio
50 ml de vino blanco de Oporto, reducido al fuego a la mitad
1 g de sal marina
2 g de sal de salmuera
3 g de azúcar glas
1 chorrito de coñac
300 g de espárragos blancos, pelados
100 g de espárragos silvestres
Sal marina, limón, azúcar morena
250 g de nísperos
80 g de azúcar morena
100 ml de zumo de naranja
1/2 vaina de vainilla
2 pechugas de paloma
Sal marina, pimienta

Marinar el hígado de oca con las especias y el vino durante 48 horas.
Ponerlo en una terrina (una vez forrada con papel de aluminio), prensarlo. Cocinar en el horno a 50 °C durante 40 minutos. Dejar enfriar y desmoldar. Cortar en cuatro lonchas y hacer cuadrados. Poner al frío.
Cocer los espárragos al dente. Escurrir y pasar brevemente por agua fría. Cortar por la mitad, secar con cuidado y dorar, con un poco de aceite, en la sartén a fuego alto.
Pelar los nísperos y cortar en ocho gajos. Caramelizar el azúcar y añadir el zumo de naranja. Añadir la vaina de vainilla y reducir. Añadir los nísperos y hervir hasta que estén tiernos.
Salpimentar las pechugas, dorarlas por la parte de la piel, ponerlas tres minutos en al horno a 180 °C. Sacar y dejar reposar dos minutos.
Colocar trasversalmente los espárragos asados en el plato y poner encima las lonchas de la terrina.
Repartir los gajos de los nísperos y verter sobre los espárragos el almíbar elaborado. Cortar con un cuchillo afilado la pechuga en lonchas muy finas y colocar éstas sobre los cuadrados de la terrina.

250 g di fegato d'oca, pulito
50 ml di porto bianco, fatto bollire e ridotto a metà
1 g di sale marino
2 g di sale da salamoia
3 g di zucchero a velo
1 spruzzo di cognac
300 g di asparagi bianchi, sbucciati
100 g di asparagi selvatici
Sale marino, limone, zucchero di canna
250 g di nespole
80 g di zucchero di canna
100 ml di succo d'arancia
1/2 stecca di vaniglia
2 petti di piccione
Sale marino, pepe

Fate marinare il fegato d'oca insieme alle spezie e l'alcol per 48 ore.
Pressatelo in una terrina (precedentemente ricoperta di pellicola) e fatelo cuocere nel forno a 50 °C per 40 minuti. Fatelo raffreddare e toglietelo dalla terrina, capovolgendola. Tagliatelo a quattro fette e stampatelo a quadrati. Fatelo raffreddare.
Fate cuocere gli asparagi al dente, insieme alle spezie e fateli brevemente raffreddare sotto l'acqua fredda. Tagliateli a metà, asciugateli con uno strofinaccio e fateli grigliare bene con poco olio.
Sbucciate le nespole e tagliateli a otto pezzi. Fate caramellare lo zucchero, deglassandolo con il succo d'arancia e fatelo cuocere e ridurre insieme alla stecca di vaniglia. Aggiungete le nespole e fatele cuocere fino a quando risulteranno morbide.
Condite i petti di piccione. Fateli rosolare dalla parte della pelle fino a farla diventare croccante e dorata ed inserite i petti per tre minuti nel forno a 180 °C. Toglieteli e fateli riposare per due minuti.
Adagiate per il lungo gli asparagi grigliati sul piatto e disponetevi la terrina sopra.
Distribuite le nespole sul piatto e nappate gli asparagi con il fondo delle nespole. Tagliate i petti di piccione con un coltello affilato a fettine sottili e distribuiteli sui piatti.

FELIX ClubRestaurant

Design: amj Design | Chef: Florian Glauert

Behrenstraße 72 | Mitte
Phone: +49 30 20 62 860
www.felix-clubrestaurant.de | info@felix-clubrestaurant.de
Subway: Unter den Linden
Opening hours: Wed–Sat 7 pm to open end
Average price: € 25
Reservation: Recommended
Cuisine: Modern Italian

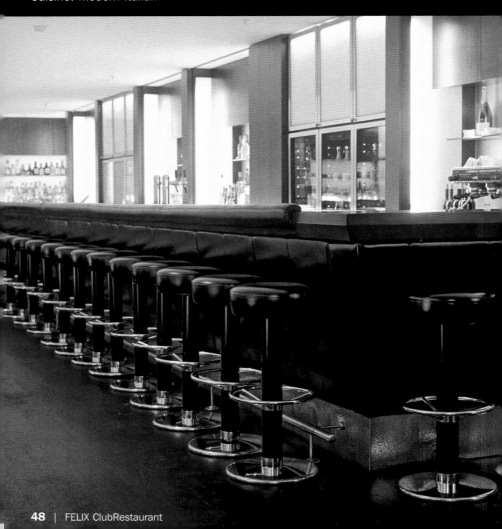

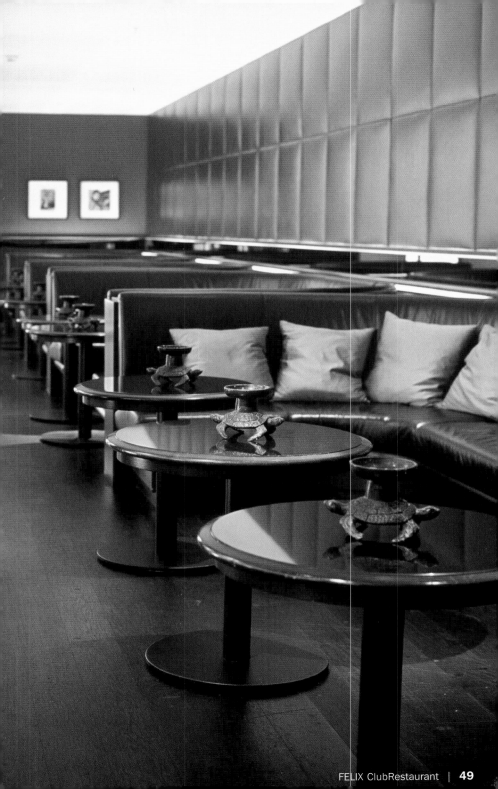

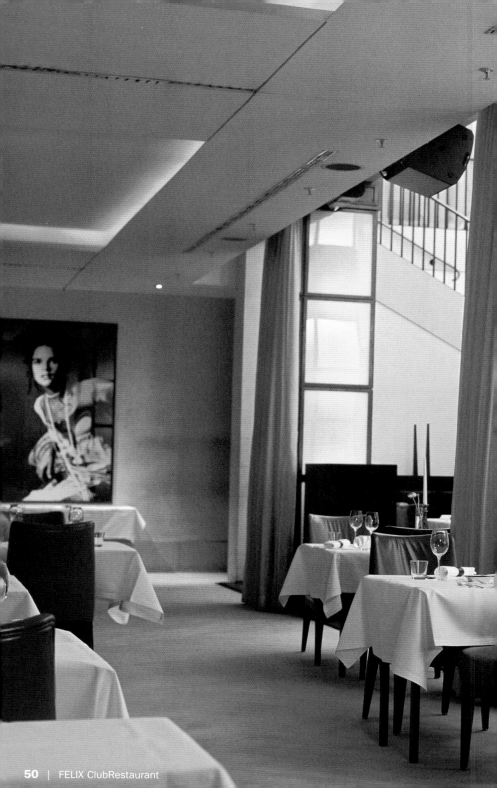

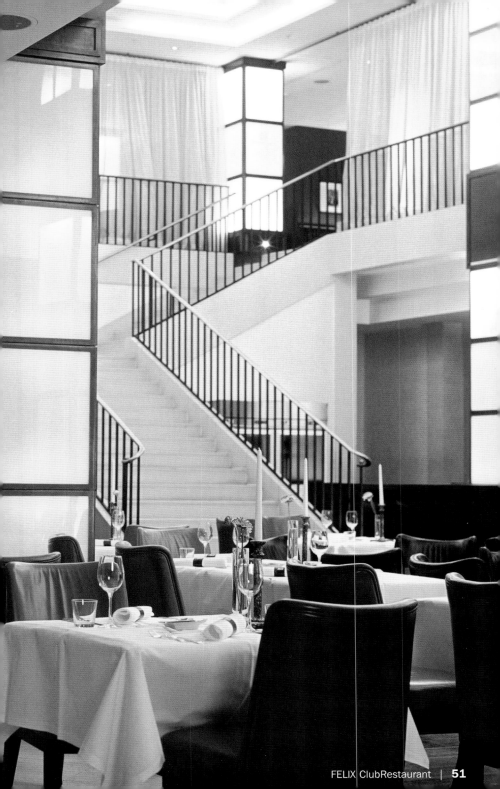

Greenwich Bar©

Design & Chef: Heiko Martinez

Gipsstraße 5 | Mitte
Phone: +49 30 28 09 55 66
Subway: Hackescher Markt
Opening hours: Every day 7 pm to 1 am
Average price: € 9
Special features: Drinks only

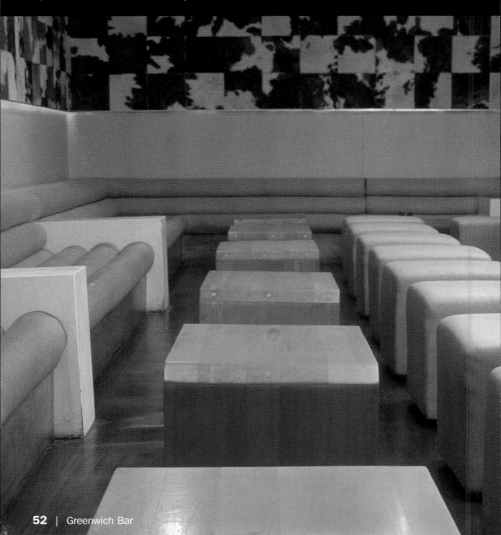

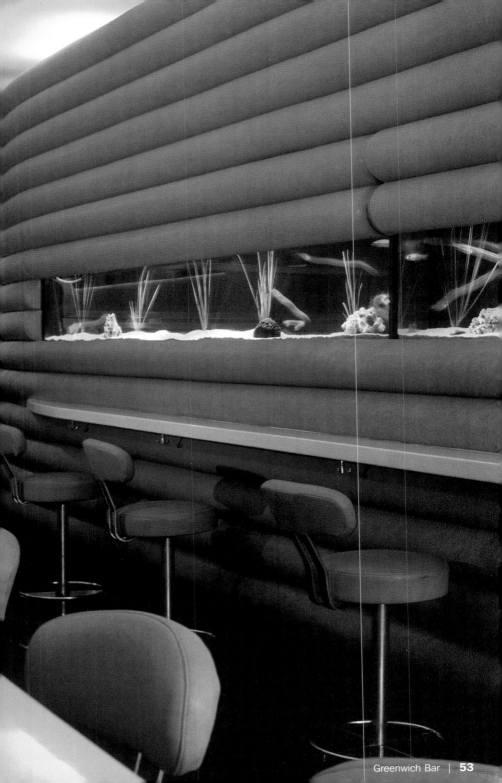

GUY

Design: Hartmut Guy | Chef: Andreas Krüger

Jägerstraße 59-60 | Mitte
Phone: +49 30 20 94 26 00
www.guy-restaurant.de | info@guy-restaurant.de
Subway: Potsdamer Platz
Opening hours: Mon–Fri Lunch 12 noon to 3 pm, Dinner 6 pm to 1 am,
Sat 6 pm to 1 am, closed on Sunday
Average price: € 50
Reservation: Recommended
Cuisine: French, classical and modern | Gault Millau prized

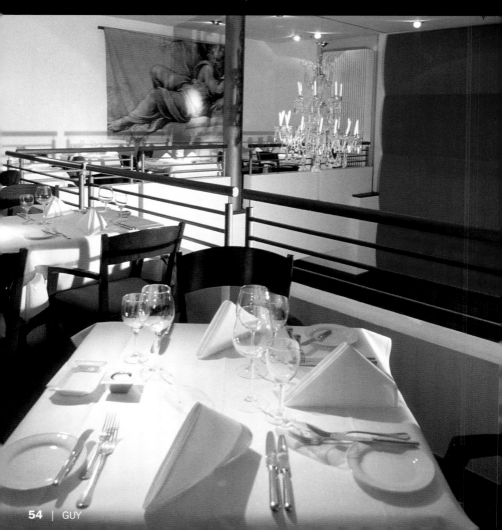

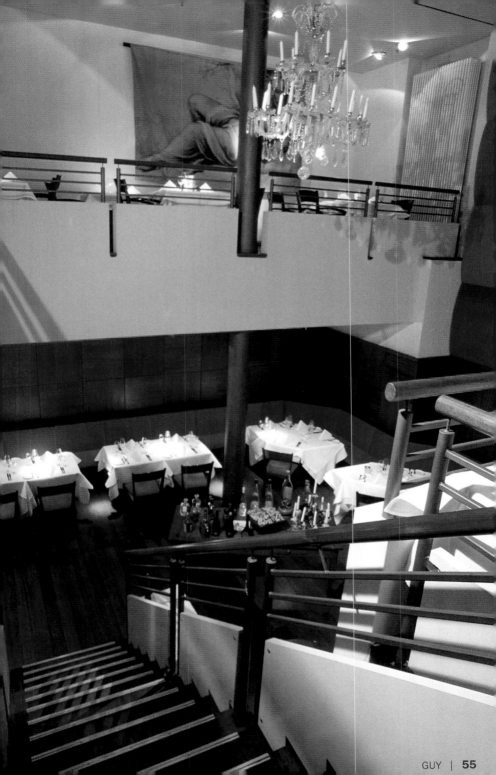

Spargel-Mosaik

mit Schwarzwälder Schinken und Rhabarberkompott

Asparagus Mosaic with Black Forest Ham
and Rhubarb Compote

Mosaïque d'asperges au jambon de la
Forêt-Noire et à la compote de rhubarbe

Mosaico de espárragos con jamón de la
Selva Negra y compota de ruibarbo

Mosaico di asparagi con prosciutto della
Foresta Nera con composto di rabarbaro

300 g Rhabarber, geschält
160 g Zucker
1 Vanilleschote
80 g Erdbeeren

16 Stangen weißen Spargel, bissfest gekocht
16 Stangen grünen Spargel, bissfest gekocht
40 g Butter
8 dünne Scheiben Schwarzwälder Schinken
4 Blätter Brickteig (im Asialaden erhältlich)
Steirisches Kürbiskernöl

Die klein geschnittenen Stangen Rhabarber mit dem Zucker vermischen und für ca. acht Stunden ruhen lassen. Danach Rhabarber und Flüssigkeit trennen, den Fond mit den Erdbeeren und der Vanilleschote aufkochen und 10 Minuten ziehen lassen. Den Fond nochmals passieren und zusammen mit dem Rhabarber kurz aufkochen lassen. Der Rhabarber sollte bissfest bleiben. Im Kühlschrank abkühlen.

1/2 lb 3 oz peeled rhubarb
5 2/3 oz sugar
1 vanilla pod
3 oz strawberries

16 white asparagus spears, cooked al dente
16 green asparagus spears, cooked al dente
1 1/2 oz butter
8 thin slices of Black Forest ham
4 pieces of block dough (available in Asia shops)
Steirisch pumpkin-seed oil

Mix the finely chopped rhubarb spears with the sugar and let it stand for approx. eight hours. After that, separate the rhubarb and the liquid, bring the juice with the strawberries and the vanilla pod to boil and let it steep for about 10 minutes. Strain the brew once more and briefly boil it together with the rhubarb. The rhubarb should be al dente. Allow to cool in the refrigerator.

Für ein Mosaik nehmen Sie zuerst ein Blatt Brickteig, bestreichen ihn mit Butter und belegen ihn dann mit zwei Scheiben Schwarzwälder Schinken.
Um später ein mosaikartiges Schnittbild zu erhalten, nehmen Sie je vier Stangen weißen und grünen Spargel, die abwechselnd in zwei Etagen übereinander gelegt werden. Jetzt zu einem festen Päckchen einrollen. Die vier Päckchen (pro Person eins) in Olivenöl und Butter goldgelb anbraten. Danach fünf Minuten bei 180 °C in den Backofen legen.
Das Rhabarberkompott auf vier Tellern anrichten. Die Spargel-Mosaike in der Mitte schräg durchschneiden und neben dem Kompott anrichten. Jetzt noch ein paar Tropfen Steirisches Kürbiskernöl um das Kompott träufeln und sofort servieren.

For one mosaic, first take a sheet of block dough, spread it with butter, and then put two pieces of Black Forest ham on it.
In order to attain the mosaic-like cross image later, take four each spears of white and green asparagus and place them on top of each other alternating in two layers. Now roll up into a firm packet. Sauté the four packets (one per person) in olive oil and butter until golden colored. After that, place in the oven at 350 °F for five minutes. Arrange the rhubarb compote on four plates.
Cut the asparagus mosaic diagonally through the middle and set it next to the compote. Now let a couple of drops of Steirisch pumpkin-seed oil trickle onto the compote and serve immediately.

300 g de rhubarbe épluchée
160 g de sucre
1 gousse de vanille
80 g de fraises

16 pointes d'asperges blanches, pas trop cuites
16 pointes d'asperges vertes, pas trop cuites
40 g de beurre
8 tranches minces de jambon de la Forêt-Noire
4 feuilles de pate à brick (disponibles dans les magasins de spécialités asiatiques)
Huile de graines de potiron Styrien

Mélanger les tiges de rhubarbe coupées avec le sucre et laisser reposer env. huit heures. Ensuite, séparer la rhubarbe du liquide, faire bouillir le fond avec les fraises et la gousse de vanille, ensuite laisser reposer pendant 10 minutes. Filtrer le fond au chinois et faire bouillir pendant quelques instants. La rhubarbe doit rester croquante. Faire refroidir au réfrigérateur.

Pour créer une mosaïque, prendre d'abord une feuille de brick, la badigeonner avec du beurre et la garnir avec deux tranches de jambon de la Forêt-Noire.
Pour obtenir plus tard une coupe en mosaïque, veuillez prendre respectivement quatre tiges d'asperges blanches et quatre tiges d'asperges vertes, qui seront superposées en alternance sur deux étages. Enrouler alors en un paquet bien ferme. Faire dorer les quatre paquets (un par personne) dans la poêle dans l'huile d'olive et du beurre. Passer ensuite au four pendant cinq minutes à 180 °C.
Servir la compote de rhubarbe sur quatre assiettes. Couper la mosaïque d'asperges au milieu en diagonal et servir à côté de la compote. Verser quelques gouttes d'huile de graines de potiron Styrien autour de la compote et servir aussitôt.

300 g de ruibarbo mondado
160 g de azúcar
1 vaina de vainilla
80 g de fresas

16 espárragos largos blancos cocidos al dente
16 espárragos largos verdes cocidos al dente
40 g de mantequilla
8 rodajas finas de jamón de la Selva Negra
4 hojas de pasta de Brick (a la venta en tiendas de productos asiáticos)
Aceite de semillas de calabacín de Estiria

Mezclar los tallos de ruibarbo cortados en pequeños pedazos con el azúcar y dejarlos reposar durante ocho horas. Luego separar el ruibarbo del líquido, cocer el fondo con las fresas y la vaina de vainilla y dejarlo reposar durante 10 minutos. Cocer el fondo junto con el ruibarbo. El ruibarbo debe cocerse de tal modo que permanezca con cierta consistencia al ser mordido.

Enfriar en el frigorífico.
Para el mosaico primeramente tome una hoja de pasta de Brick, úntela de mantequilla y guarnézcala con dos rodajas de jamón de la Selva Negra. Para que después le quede una figura de apariencia semejante a un mosaico sírvase tomar cuatro espárragos blancos y verdes y colóquelos en dos capas unos sobre otros. Ahora debe enrollar todo y formar así un rodillo compacto. Los cuatro rodillos (uno por persona) han de dorarse en aceite de oliva y mantequilla; despúes han de cocerse durante unos cinco minutos en el horno a 180 °C.
Disponer la compota de ruibarbo en cuatro platos. Disponer los mosaicos de espárragos en el centro cortados oblicuamente junto a la compota. Ahora rocíe unas gotas de aceite de semillas de calabacín de Estiria en la compota. Servir inmediatamente.

300 g di gambi di rabarbaro pelati
160 g di zucchero
1 stecca di vaniglia
80 g di fragole

16 gambi di asparagi bianchi, cotti al dente
16 gambi di asparagi verdi, cotti al dente
40 g di burro
8 fettine sottili di prosciutto della Foresta Nera
4 fogli di pasta tipo strudel (la troverete già pronta negli Asia shop)
Olio di semi di zucca della Stiria

Mescolate i gambi di rabarbaro tagliati a pezzettini con lo zucchero e lasciateli riposare per otto ore circa. Dopodiché separate il rabarbaro dal liquido che si è formato, fate deglassare il fondo con le fragole e la stecca di vaniglia e lasciate cuocere al tutto per 10 minuti a fuoco bassissimo. Passate il fondo nuovamente attraverso il setaccio e fatelo bollire brevemente insieme al rabarbaro. Il rabarbaro dovrebbe rimanere al dente. Fatelo raffreddare nel frigorifero.
Per creare un mosaico, prendete prima un foglio di pasta tipo strudel, pennellatelo con il burro e stendeteci due fettine di prosciutto della Foresta Nera. Per poter ottenere il mosaico, prendete quattro gambi di asparagi bianchi e quattro gambi di quelli verdi e poneteli ad uno strato sopra l'altro, alternandoli tra di loro. Ora rotolateli stringendo fino ad ottenere un pacchetto compatto. Fate rosolare i quattro pacchetti (uno a persona) nell'olio di oliva mescolato con il burro fino ad ottenere un colore dorato. Dopodiché inserite i rotoli nel forno a 180 °C per cinque minuti.
Distribuite il composto di rabarbaro su quattro piatti. Praticate un taglio diagonale al centro del mosaico di asparagi e disponetelo accanto al composto di rabarbaro. Ora fate cadere alcune gocce di olio di semi di zucca della Stiria attorno al composto di rabarbaro e servite immediatamente in tavola.

Kuchi

Design: Hyunjung-kim, The Duc Ngo, Truong Ngu
Chef: The Duc Ngo

Gipsstraße 3 | Mitte
Phone: +49 30 28 38 66 22
www.kuchi.de | mitte@kuchi.de
Subway: Hackescher Markt
Opening hours: Every day 12 noon to 12 midnight
Average price: € 10
Cuisine: Asian fusion

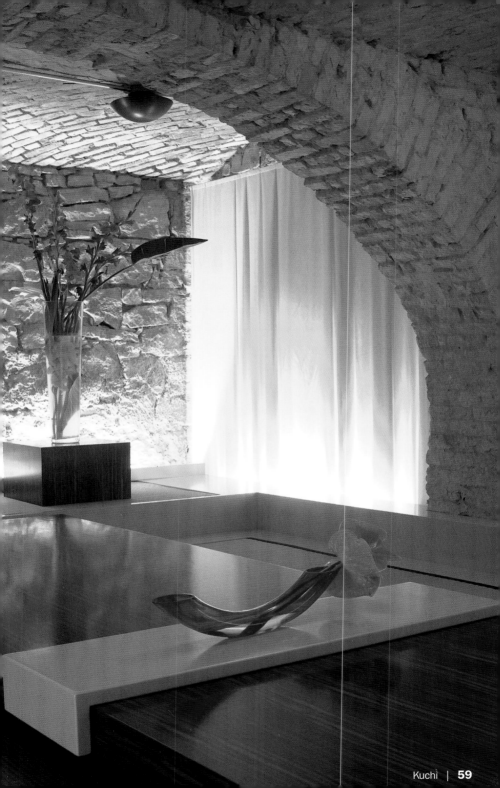

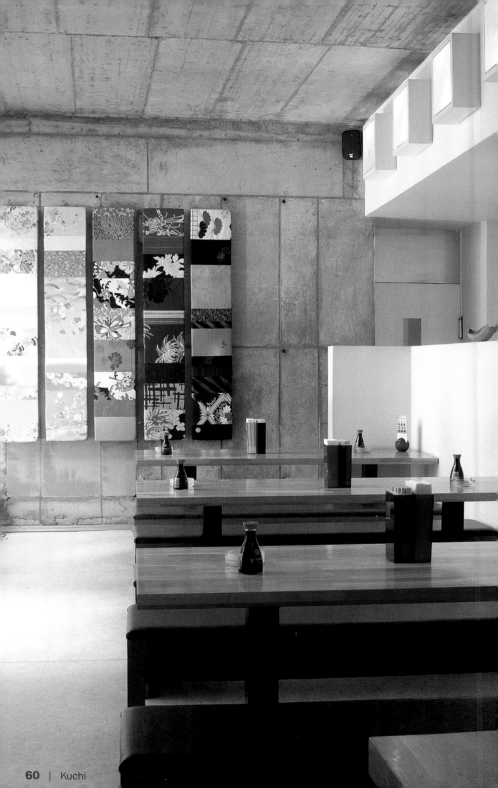

New Style
Sashimi

5 Scheiben Yellow Tail
50 ml Sojasoße
1/2 frische Zitrone
Koriander
1 Chilischote

Schneiden Sie den Yellow Tail in ca. 3 x 3 cm
große und 5 mm dicke Stücke. Die Stücke
nebeneinander anrichten. Ein Blatt Koriander und
eine dünne Scheibe Chillischote jeweils auf die
Stücke legen. Den Saft einer halben Zitrone mit
der Sojasoße und einem Schuss Wasser vermi-
schen. Zum Schluss wird die Marinade über den
Fisch gegossen.

5 slices of yellow tail
50 ml soy sauce
1/2 fresh lemon
Cilantro
1 Chili

Cut the yellow tail in 1.2-inch squares that are 2
inches thick. Lay out squares in a row. Place a
cilantro leaf and a thin slice of chili on each
square. Mix the juice of 1/2 lemon with the soy
sauce and a dash of water. Pour marinade over
fish.

5 tranches de sériole
50 ml de sauce au soja
1/2 citron frais
Coriandre
1 gousse de chili

Coupez la sériole en morceaux d'environ 3 x 3 cm
de taille et d'un demi-centimètre d'épaisseur.
Disposer les morceaux les uns à côté des autres.
Déposer une feuille de coriandre et une tranche
fine de chili sur chaque morceau. Mélanger le jus
d'un demi-citron à la sauce au soja et avec un
peu d'eau. Verser ensuite la marinade sur le pois-
son.

5 lonchas de serviola (yellow tail)
50 ml de salsa de soja
1/2 limón fresco
Cilantro
1 guindilla

Cortar el pescado en cuadrados de 3 x 3 cm y
con un grosor de 1/2 cm. Colocar los trozos en los
platos, uno al lado de otro. Poner sobre cada
trozo una hoja de cilantro y una rodaja muy fina
de guindilla. Mezclar el zumo de limón con la
salsa de soja y un chorrito de agua. Verter, final-
mente, esta marinada sobre el pescado.

5 fettine di ricciola
50 ml di salsa di soia
1/2 limone fresco
Coriandolo
1 peperoncino fresco

Tagliate il Yellow Tail a fettine da ca. 3 x 3 cm, con
uno spessore di ca. 1/2 cm. Disponete i pezzi uno
accanto all'altro. Appoggiate una foglia di corian-
dolo e una sottile fettina di peperoncino su ogni
pezzo. Mescolate il succo di mezzo limone fresco
con la salsa di soia ed uno sprizzo di acqua. In
fondo, versate la marinata sul pesce.

Design: Heinrich Baller, Volkmar Thieme, Klaus Bartels
Chef: Sebastian Zeitler

Rosenthaler Straße 36 | Mitte
Phone: +49 30 27 58 20 35
www.kulakarma.de | info@kulakarma.de
Subway: Hackescher Markt
Opening hours: Mon–Fri 7 pm to 12 midnight, Sat–Sun 7 pm to 1 am
Average price: € 12
Reservation: Recommended
Cuisine: Asian, Californian

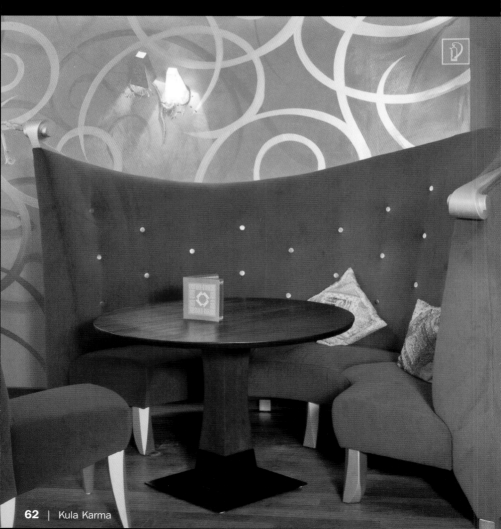

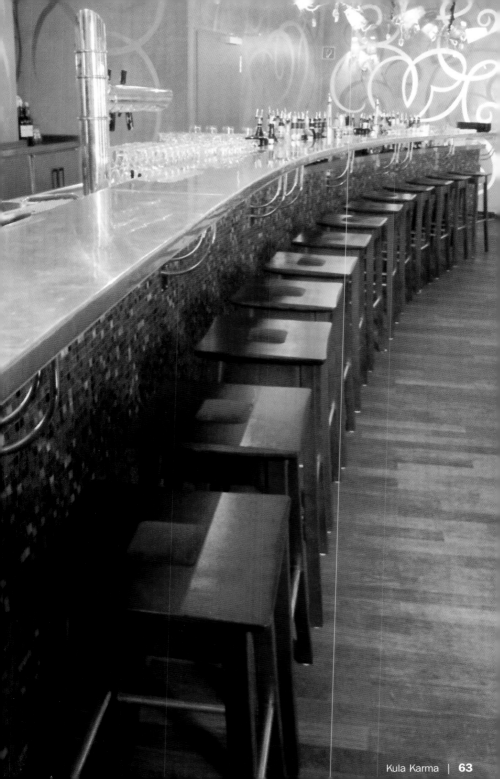

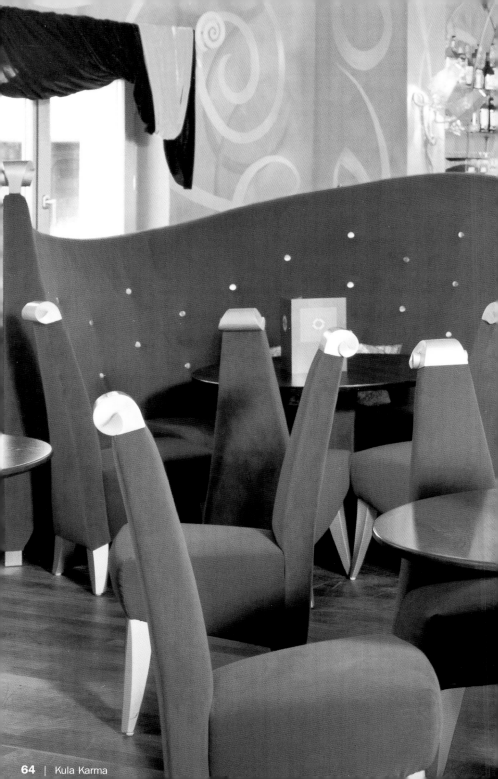

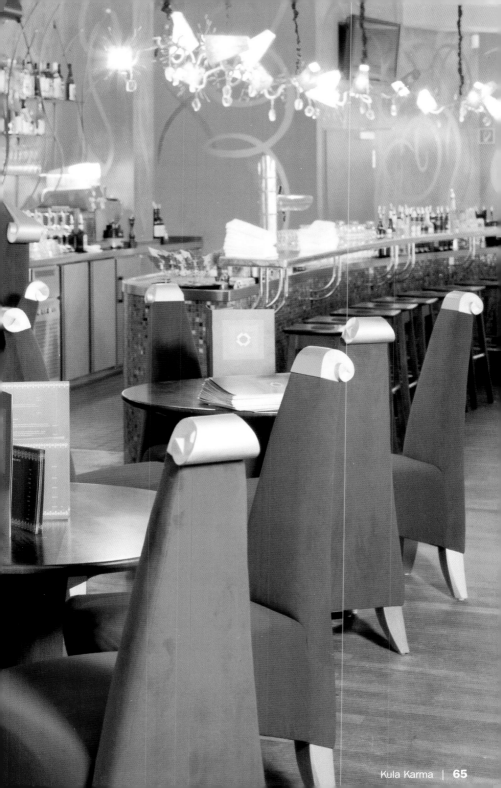

Le Bar du Paris Bar

Design: Hoidn Wang Partner | Chef: Reinald Nohal, Michel Würthle

Kantstraße 152 | Charlottenburg
Phone: +49 30 31 01 50 94
Subway: Uhlandstraße, Savignyplatz
Opening hours: 6 pm to 2 am
Average price: € 25
Cuisine: Bistro French and classical

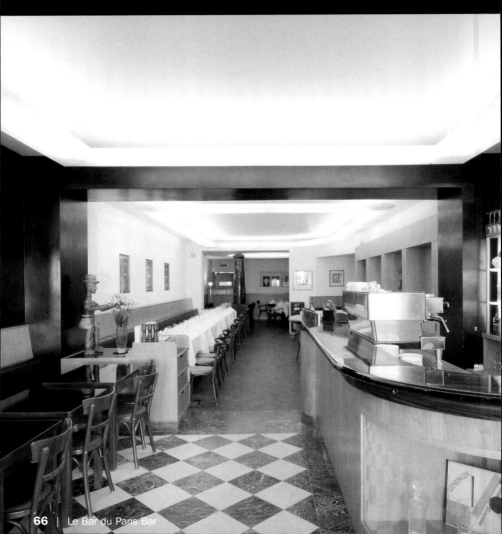

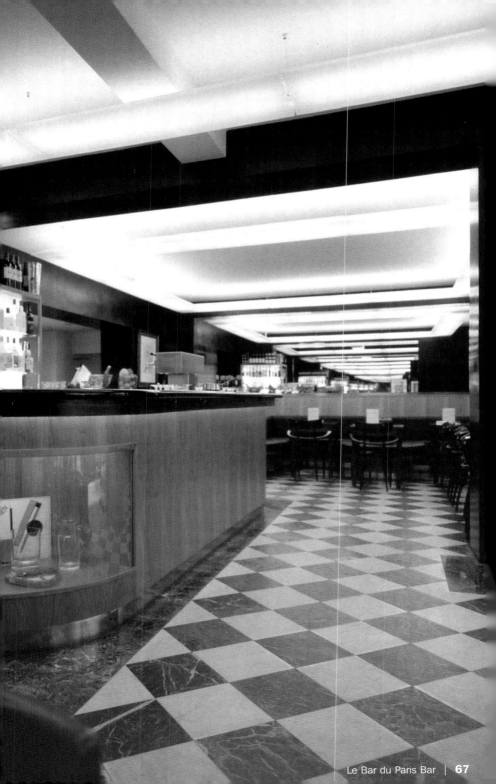

Le Bar du Paris Bar | **67**

Lutter & Wegner

Design: Elvira Bach, Salomé, Rainer Fetting, Josef Laggner
Chef: Nicole Todoroff

Charlottenstraße 56 | Mitte
Phone: +49 30 2 02 95 40
www.l-w-berlin.de | info@l-w-berlin.de
Subway: Stadtmitte
Opening hours: Every day 11 am to 2 am
Average price: € 12–20
Reservation: Recommended
Cuisine: German regional with a slight Austrian accent

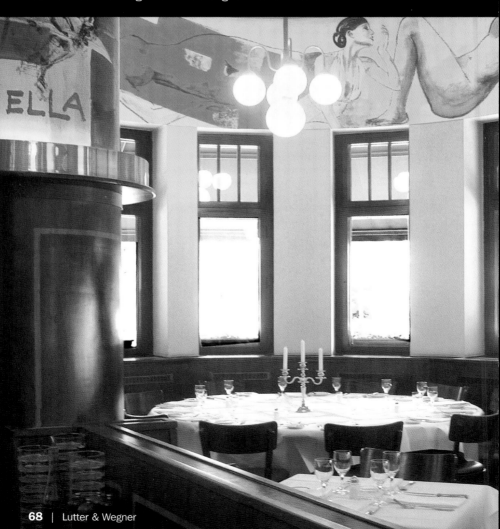

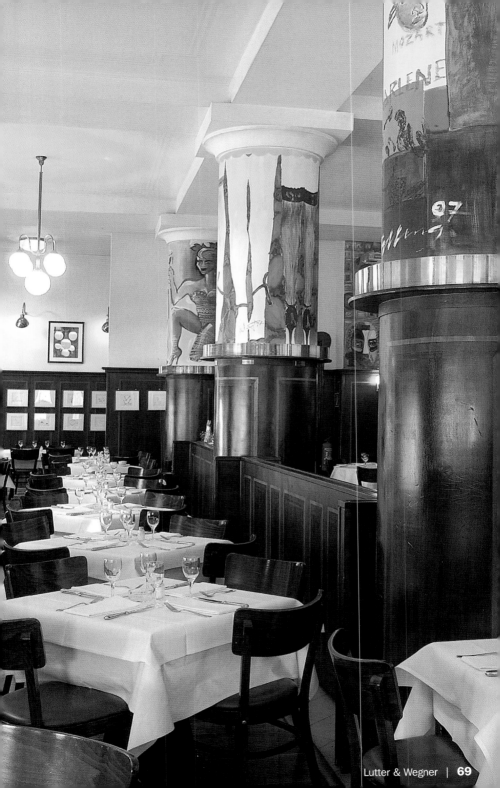

Berliner
Sauerbraten

Berliner Sauerbraten (Braised Beef)
Rôti de viande marinée à la berlinoise
Asado agrio al estilo berlinés
Arrosto all'agro alla berlinese

1 kg Rindfleisch aus der Keule

Herstellen der Beize mit folgenden Zutaten:
Karotten, Sellerie, Zwiebeln (grob gewürfelt),
Schalotten, Porree, Frühlingslauch, Petersilien-
wurzeln
3 Teile Rotweinessig, 1 Teil Himbeeressig,
1/3 Teil Balsamico-Essig
Rotwein, Rinderbrühe, Jus, Tomatenmark, Salz,
Pfeffer, Majoran, Kümmel, Wacholder, Koriander,
Lorbeer, Piment, Zucker

Diese Zutaten werden in einem Topf mit Deckel
ca. eine halbe Stunde leicht geköchelt. Danach
mit der leicht abgekühlten Beize das Fleisch mari-
nieren, darauf achten, dass das Fleisch komplett
mit Beize bedeckt ist.

Zwei Tage kühl stellen.

Das Fleisch nun aus der Beize nehmen, mit
einem Küchentuch trockenreiben, salzen, pfeffern
und von allen Seiten gut anbraten. Die Gewürze
aus der Beize und das Gemüse mit anrösten und
mit einem Viertel der Beize ablöschen. Den
Braten mit Fleischbrühe aufgießen und ca. 2,5–3
Stunden langsam weich schmoren. Ist der
Sauerbraten schön weich, das Fleisch heraus-
nehmen, die Soße mit Zitronensaft und etwas
Zucker abschmecken, mit Butter und Mondamin
abziehen. Die Sauerbratensoße gründlich durch
ein Sieb seien, etwa fünf Minuten ziehen lassen
und abschmecken.

2 lbs 3 oz beef from the round

Preparation of the marinade with the following
ingredients:
Carrots, celeriac, onions (coarsely diced), shal-
lots, leeks, spring onions, parsley roots
3 parts red wine vinegar, 1 part raspberry vinegar,
1/3 parts balsamic vinegar
Red wine, beef broth, jus, tomato paste, salt,
pepper, marjoram, caraway, juniper, coriander,
bay leaf, pimento, sugar

Simmer these ingredients in a covered pot for
about half an hour. Then cool slightly and mari-
nate meat, making sure that the meat is com-
pletely covered by the marinade.

Chill for two days.

Remove the meat from the marinade and rub dry
with paper towel. Salt and pepper it, then sauté it
well on all sides. Remove the spices from the
marinade and sauté them and the vegetables
along with the meat. Add one quarter of the mari-
nade. Pour broth over beef and stew slowly for
2.5 to 3 hours until tender. Once the sauerbraten
is tender, remove meat, add lemon juice and a bit
of sugar to the jus, and thicken with butter and
starch. Strain sauerbraten gravy well, simmer five
minutes, and add spices to taste.

1 Kg de boeuf de la cuisse

Préparation de la marinade avec les ingrédients suivants :
Carottes, céleri, oignons (en gros cubes), échalotes, poireau, oignons printaniers, racines de persil
3 volumes de vinaigre de vin rouge, 1 volume de vinaigre de framboise, 1/3 de volume de vinaigre balsamique
Vin rouge, bouillon de boeuf, jus, purée de tomate, sel, poivre, marjolaine, cumin, genièvre, coriandre, laurier, piment, sucre

Ces ingrédients doivent être mijotés à feu doux dans une casserole avec couvercle durant environ une demi-heure. Mariner ensuite la viande avec la marinade légèrement refroidie en veillant à ce que la viande baigne complètement dans la marinade.

Mettez deux jours au froid.

Retirer maintenant la viande de la marinade, sécher avec un torchon, saler, poivrer et faire bien cuire sur tous les côtés. Faire blondir les fines herbes de la marinade et les légumes avec la viande, arroser avec un quart de la marinade et verser du bouillon de viande sur le rôti ; braiser lentement et attendrir pendant environ deux et demi à trois heures. Une fois que le rôti de viande marinée est bien tendre, sortir la viande, assaisonner la sauce avec du jus de citron et un peu de sucre, et faire décanter avec du beurre et de la Maïzena. Filtrer soigneusement la sauce du rôti de viande marinée, laisser reposer environ cinq minutes et assaisonner.

1 kg de carne de vaca de la pierna

Preparación de la marinada con los siguientes ingredientes:
Zanahorias, raíz de apio, cebolla (en dados grandes), chalotas, puerro, cebolletas, raíz de perejil
3 partes de vinagre de vino tinto, 1 parte de vinagre de frambuesa, 1/3 parte de vinagre balsámico
Vino tinto, caldo de carne, caldo concentrado, concentrado de tomate, sal, pimienta, mejorana, comino, bayas de enebro, cilantro, hoja de laurel, pimienta de Jamaica, azúcar

Dejar hervir a fuego muy lento y con la cacerola tapada todos estos ingredientes durante 1/2 hora a fuego muy lento. Verter la marinada ligeramente enfriada sobre la carne, asegurándose de que la carne quede cubierta por completo.

Dejar reposar en lugar fresco durante dos días.

Sacar la carne de la marinada, secar con un paño de cocina, salpimentar y dorarla a fuego vivo. Añadir las especias de la marinada y la verdura y dorar todo. Añadir una cuarta parte de la marinada y caldo de carne. Dejar estofar durante 2,5 a 3 horas hasta que la carne esté tierna. Sacar la carne en cuanto esté tierna. Añadir a la salsa zumo de limón y un poco de azúcar, espesar la salsa con maizena y mantequilla. A continuación colarla, dejar hervir a fuego muy lento durante unos cinco minutos. Probar.

1 kg di carne di manzo della coscia

Preparate la marinata con i seguenti ingredienti:
carote, sedano, cipolle (tagliata grossolanamente a dadi), scalogne, porro, cipolline, radici di prezzemolo
3 parti di aceto di vino rosso, 1 parte di aceto ai lamponi, 1/3 parte di aceto balsamico
Vino rosso, brodo di manzo, fondo di carne, concentrato di pomodoro, sale, pepe, maggiorana, cumino, bacche di ginepro, coriandolo, alloro, pimento, zucchero

Fate cuocere questi ingredienti coperchiati a fuoco basso per ca. mezz'ora. Dopodiché immergete la carne nella marinata leggermente raffreddata, facendo attenzione perché la carne sia completamente coperta dalla marinata.

Mettetela al fresco per due giorni.

Ora togliete la carne dalla marinata, asciugatela con uno strofinaccio, salate e pepatela e fatela rosolare bene da tutte le parti. Aggiungete le spezie e le verdure della marinata, facendole imbiondire. Dopodiché spruzzatele con un quarto del liquido della marinata ed aggiungete del brodo di carne. L'arrosto dovrà cuocere lentamente per ca. 2,5 a 3 ore fino a quando risulterà bello morbido. Ora togliete la carne, aromatizzate la salsa con il succo di limone e poco zucchero e fatela addensare con il burro e la farina di fecola. Fate passare accuratamente la salsa dell'arrosto in salmì attraverso il setaccio e fatela riposare per ca. cinque minuti, dopodiché aggiustatela.

Manzini

Design: Hoffmann & Krug Architekten | Chef: Jochen Bäusch

Reinhardtstraße 14 | Mitte
Phone: +49 30 28 04 55 10
www.manzini-mitte.de | post@manzini-mitte.de
Subway: Oranienburger Tor, Friedrichstraße
Opening hours: Every day 9 am to 7 pm
Average price: € 12–20
Reservation: Recommended
Cuisine: Alpine, Mediterranean

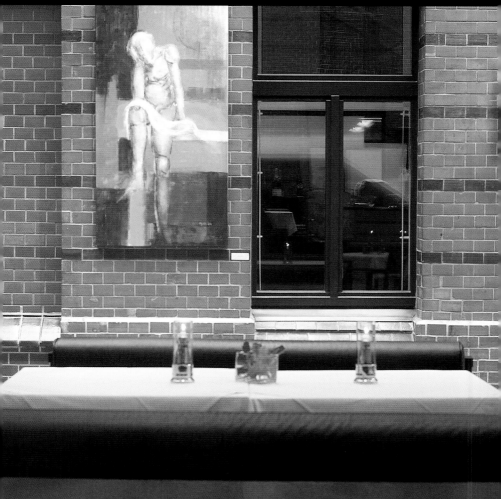

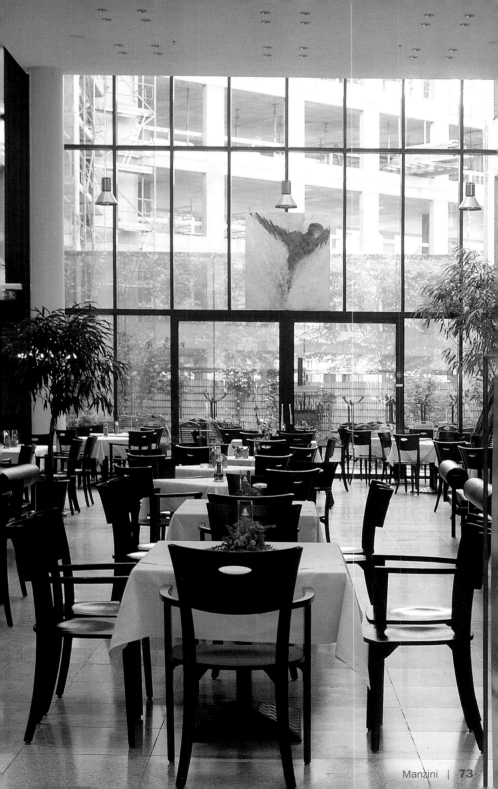

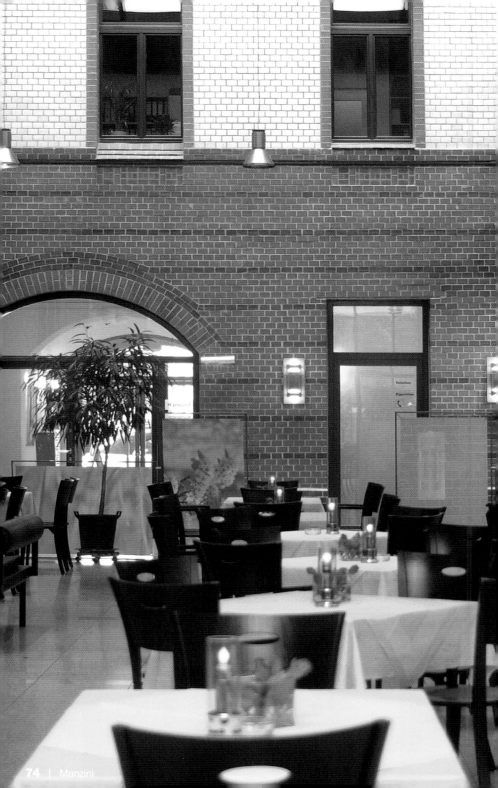

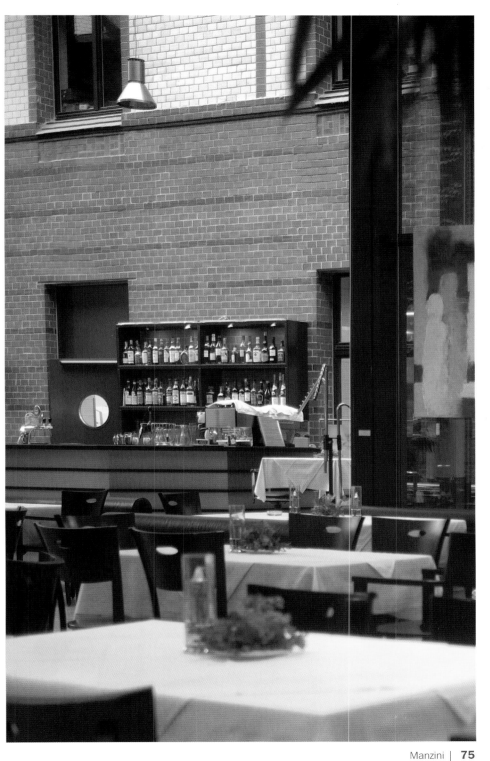

Margaux

Designer: Johanne Nalbach | Chef: Michael Hoffmann

Unter den Linden 78 | Mitte
Phone: +49 30 22 65 26 11
www.margaux-berlin.de | info@margaux-berlin.de
Subway: Unter den Linden
Opening hours: Thu–Sat 12 noon to 2 pm, Mon–Sat 7 pm to 12 midnight
closed on Sunday
Average price: € 30
Cuisine: French avant-garde and classical | Gault Millau prized

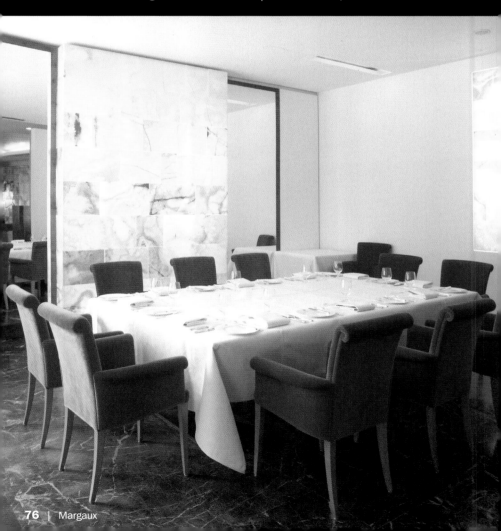

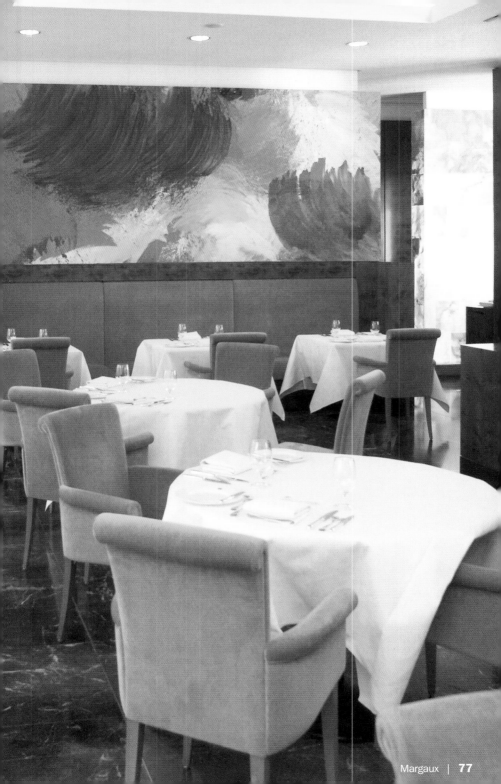

Maxwell

Design: Tina Gier, Werner Többen | Chef: Uwe Popall

Bergstraße 22 | Mitte
Phone: +49 30 2 80 71 21
www.mxwl.de | maxwell.berlin@t-online.de
Subway: Rosenthaler Platz
Opening hours: Lunch Mon–Sat 12 noon to 3 pm, Dinner every day 6 pm to 1 am
Average price: € 25
Reservation: Recommended
Cuisine: French, Mediterranean (modern)

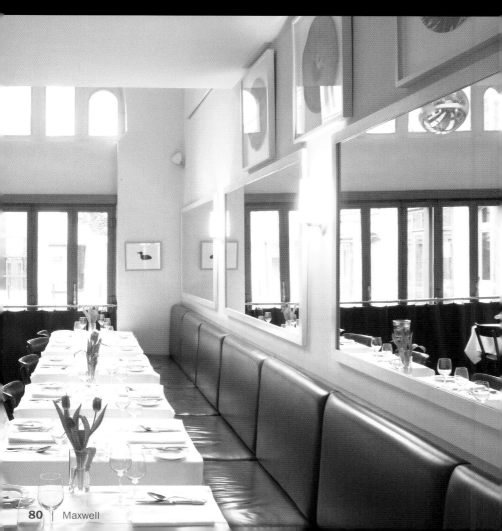

Chef

Leiter Leiter

Angestellter Angestellter Angestellter

Mitarbeiter Mitarbeiter Mitarbeiter Mitarbeiter Mitarbeiter Mitarbeiter

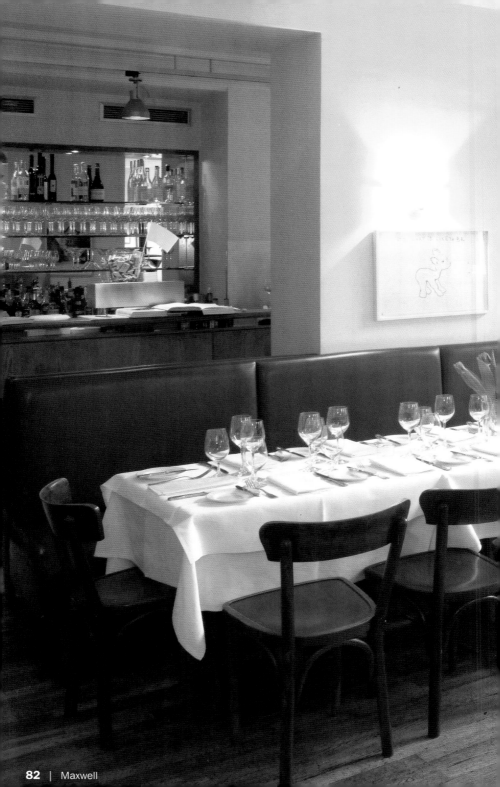

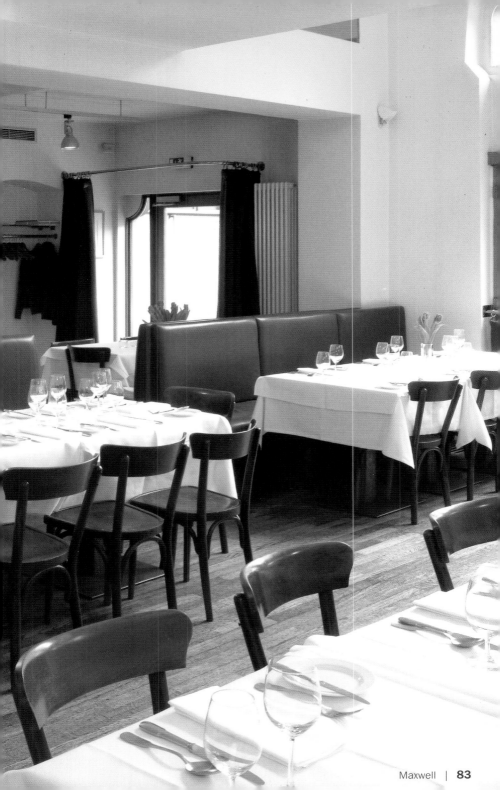

Monsieur Vuong

Design: Gesellschaft für bessere Möbel / Büro 213
Chef: Dat Vuong

Alte Schönhauser Straße 46 | Mitte
Phone: +49 30 30 87 26 43
www.monsieurvuong.de | indochina@monsieurvuong.de
Subway: Hackescher Markt
Opening hours: Mon–Sat 12 noon to 12 midnight, Sun 2 pm to 12 midnight
Average price: € 7
Cuisine: Modern Indochinese

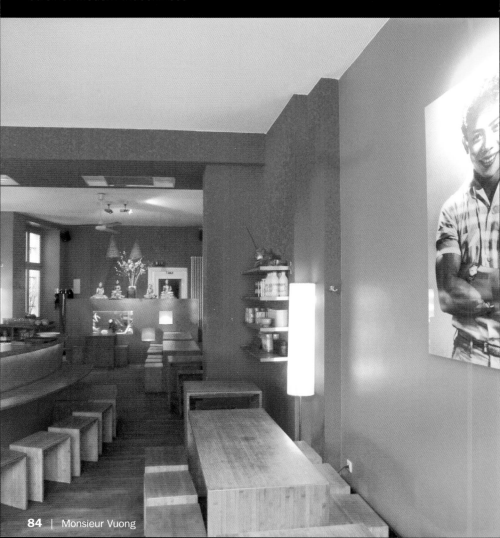

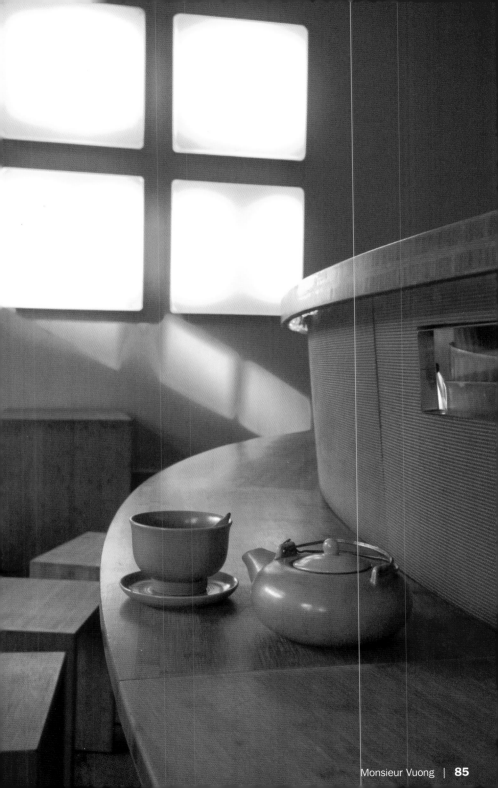

Curry Saigon

400–500 g Hühnerbrustfilet
2–3 EL Fischsauce
3 fein gehackte Knoblauchzehen
3–4 rote, fein geschnittene Chilischoten
Pflanzenöl zum Braten

1 kleine Dose Kokosmilch
1 EL rote Currypaste
100 g fein geschnittenes Zitronengras
2–3 in Streifen geschnittene Limettenblätter
2 EL Palmzucker
200 g geschälte Ananas oder rote Süßkartoffeln
(je nach Geschmack)
Geröstete und gehackte Erdnüsse
Frisch gehackter Koriander
Duftreis

Das Hühnerbrustfilet für ca. sechs Stunden in einen Sud aus Fischsauce, Knoblauch und feingeschnittenen Chillischoten legen. Danach das Fleisch in Streifen schneiden und in Öl anbraten.

Etwas Pflanzenöl in einem Wok erhitzen und die Currypaste dazugeben. Dann folgen unter ständigem Rühren die Kokosmilch und ca. 50 ml Wasser. Nicht zu viel Kokosmilch verwenden. Der Kokosgeschmack darf das Gericht nicht dominieren.
Anschließend das Fleisch und das geschnittene Zitronengras hinzugeben und alles 10–15 Minuten köcheln lassen. Abgeschmeckt wird das Curry mit Fischsauce und Palmzucker. Ganz zum Schluss kommen die geschnittenen Limettenblätter und Ananas- oder Süßkartoffelstücke hinzu. Entscheiden Sie sich für Süßkartoffeln, müssen Sie diese vorher in Scheiben schneiden und kurz anbraten.
Vor dem Servieren die gerösteten und gehackten Erdnüsse sowie etwas Koriander über das Curry streuen.
Zum Curry Saigon gehört natürlich feiner Duftreis. In Vietnam isst man auch gerne frisches, knuspriges Baguette dazu.

14–17 1/2 oz chicken breast filet
2–3 tbsp fish sauce
3 finely chopped garlic cloves
3–4 finely chopped red chile peppers
Vegetable oil for frying

1 small can coconut milk
1 tbsp red curry paste
3 1/2 oz finely chopped lemon grass
2–3 lime leaves, cut into strips
2 tbsp palm sugar
7 oz peeled pineapple or red sweet potato
(as desired)
Roasted and chopped peanuts
Freshly chopped cilantro
Aromatic rice

Marinate the chicken breast filet in the fish sauce, garlic and finely chopped chile peppers for about six hours. Then, cut the meat into strips and sauté briefly in oil. Heat some vegetable oil in a wok or pan and add the curry paste. While constantly stirring, add the coconut milk and about 50 ml water. Do not use too much coconut milk. The coconut flavor should not dominate the dish.
Then add the chicken and chopped lemon grass and simmer together for 10–15 minutes. Add the fish sauce and palm sugar. Finally, add the lime leaves and pineapple or sweet potato. If you are using sweet potato, you must first slice and briefly sauté it.
Before serving, sprinkle the curry with the roasted peanuts and cilantro.
Serve aromatic rice with the Curry Saigon. In Vietnam, one also often eats fresh, crispy baguette with it.

400–500 g de filet de blanc de poulet
2–3 c. à soupe de poisson
3 gousses d'ail hachées finement
3–4 gousses de chili rouge, coupées finement
Huile végétale pour faire frire

1 petite boîte de lait de coco
1 c. à soupe de pâte de curry rouge
100 g de citronnelle coupé finement
2–3 feuilles de citron vert coupées en lamelles
2 c. à soupe de sucre de palmier
200 g d'ananas épluché ou de patates douces
rouges (suivant les goûts)
Cacahuètes grillées et concassées
Coriandre hachée finement
Riz thaïlandais

Faire mariner le filet de blanc de poulet pendant
environ six heures dans un jus de sauce de pois-
son, d'ail et de gousses de chili coupées finement.
Couper ensuite la viande en lamelle et faire frire

dans de l'huile. Faire chauffer un peu d'huile
végétale dans un récipient (wok) et y ajouter la
pâte de curry. Versez ensuite en remuant le lait de
coco et environ 50 ml d'eau. N'utilisez pas trop
de lait de coco. Le goût de coco ne doit pas domi-
ner le plat.
Ajoutez ensuite la viande, la citronnelle et faîtes
cuire le tout à feux doux pendant 10 à 15 minu-
tes. Le curry est assaisonné avec la sauce de
poisson et le sucre de palmier. Tout à la fin, il faut
ajouter les feuilles de citron vert coupées et les
morceaux d'ananas ou de patate douce. Si vous
vous décidez pour les patates douces, vous devez
couper celles-ci en tranche auparavant et les sai-
sir dans la poêle.
Avant de servir, répandez les cacahuètes hachées
et grillées ainsi qu'un peu de coriandre sur le curry.
On mange bien sûr le curry Saigon avec du riz
thaïlandais fin. Au Vietnam, on accompagne
celui-ci d'un morceau de baguette fraîche et
croustillante.

400–500 g de filetes de pechuga de pollo
2–3 cucharadas de salsa de pescado
3 dientes de ajo picados finamente
3–4 guindillas cortadas en rodajitas
Aceite vegetal (para freír)

1 lata pequeña de leche de coco
1 cucharada de pasta de curry rojo
100 g de cidronela cortada muy finamente
2–3 hojas de lima en tiras
2 cucharadas de azúcar de caña
200 g de piña pelada o de boniatos (según el
gusto)
Cacahuetes tostados y picados
Cilantro fresco picado
Arroz aromático

Dejar reposar los filetes de pechuga de pollo
durante apróx. seis horas en una decocción de
salsa de pescado, ajo y guindillas cortadas. A con-
tinuación, cortar la carne en tiras y freír en el acei-

te. Calentar el aceite vegetal en un recipiente
(wok). Agregar primero la pasta de curry y verter
luego la leche de coco y aprox. 50 ml de agua
removiendo la mezcla continuamente. No utilizar
demasiada leche de coco, para que no domine el
sabor a coco.
A continuación, añadir la carne, la cidronela y
dejar cocer lentamente durante 10–15 minutos.
Sazonar el curry al gusto agregando algo de salsa
de pescado y el azúcar de caña. Por último, aña-
dir las hojas de lima cortadas y los trozos de piña
o de boniato. Si se ha optado por los boniatos, se
cortarán previamente en lonchas y se freirán
unos instantes.
Antes de servir el curry, espacir un poco de cilan-
tro y los cacahuetes tostados y picados encima.
El curry saigonés se sirve siempre con arroz aró-
matico de alta calidad. En Vietnam, se suele
comer con pan fresco y crujiente.

400–500 g di filetti di petto di pollo
2–3 cucchiai di salsa di pesce
3 spicchi di aglio finemente tritati
3–4 peperoncini rossi, finemente tagliati
Olio di semi per la frittura

1 piccola lattina di latte di cocco
1 cucchiaio di pasta di curry rossa
100 g di lemongrass finemente mondato
2–3 foglie di limette tagliate a strisce
2 cucchiai di zucchero di palma
200 g di ananas sbucciata o patate dolci rosse
(secondo i Vs. gusti)
Arachidi arrostiti e tritati
Coriandolo fresco tritato
Riso profumato

Immergete i filetti di petto di pollo per circa sei
ore in una marinata composta dalla salsa di
pesce, aglio e peperoncino finemente tagliato.
Dopodiché tagliate la carne a strisce e fatela

rosolare con l'olio. Scaldate poco olio di semi in
un recipiente (wok) ed aggiungete la salsa di
curry. Seguono – mescolando in continuazione –
il latte di cocco e ca. 50 ml di acqua. Non utiliz-
zate troppo latte di cocco. Il sapore del cocco non
deve dominare la pietanza.
Successivamente aggiungete la carne, il lemon-
grass tagliato e lasciate cuocere il tutto a fuoco
moderato per 10 a 15 minuti. Aggiustate il curry
con la salsa di pesce e lo zucchero di palma. In
fondo si aggiungono le foglie tagliate delle limet-
te ed i pezzi di ananas o delle patate dolci. Se
doveste usare le patate dolci, dovete prima taglia-
rle a fettine e farle rosolare brevemente.
Prima di servire in tavola, spolverizzate il curry con
gli arachidi e poco coriandolo.
Ovviamente, fa parte del Curry Saigon il delicato
riso profumato. In Vietnam si gusta questa
pietanza anche con il pane baguette freso e croc-
cante.

Newton Bar

Design: Hans Kollhoff | Chef: Josef Laggner, Josh Friedrich

Charlottenstraße 57 | Mitte
Phone: +49 30 20 29 54 21
www.newton-bar.de | info@newton-bar.de
Subway: Stadtmitte
Opening hours: Sun–Thu 10 am to 3 pm, Fri–Sat 10 am to 4 pm
Average price: € 15
Reservation: Recommended

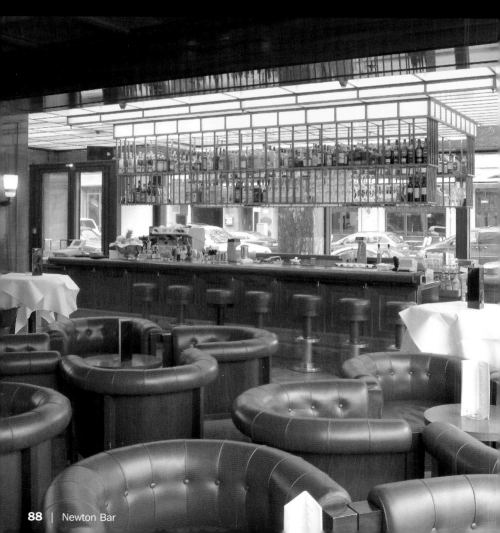

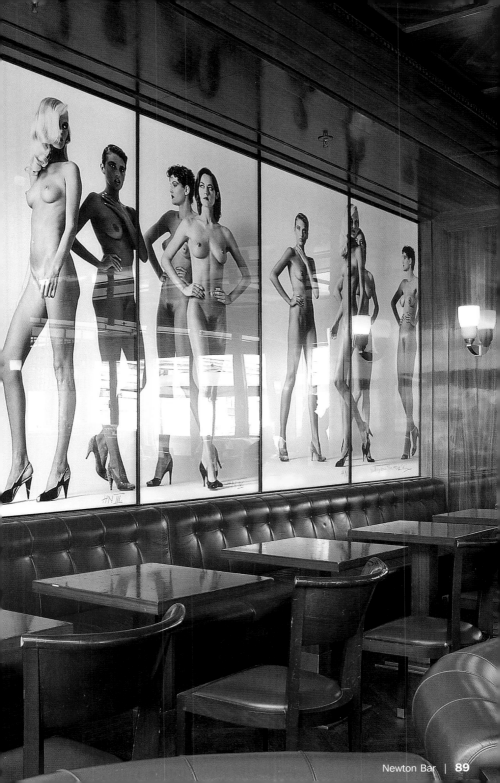

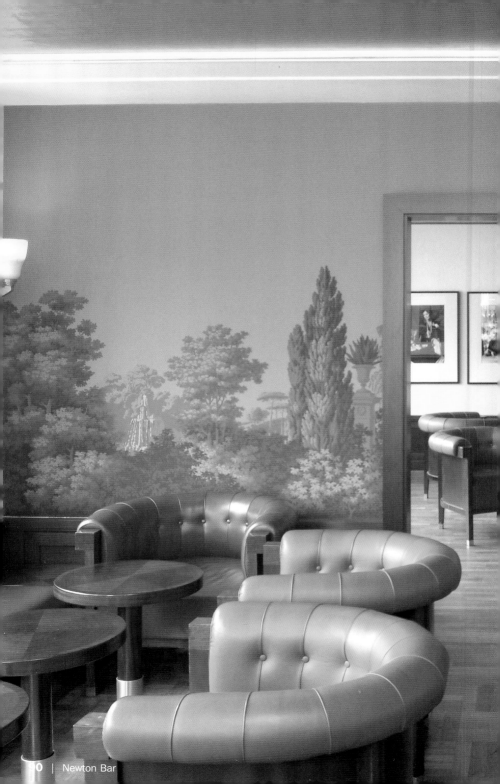

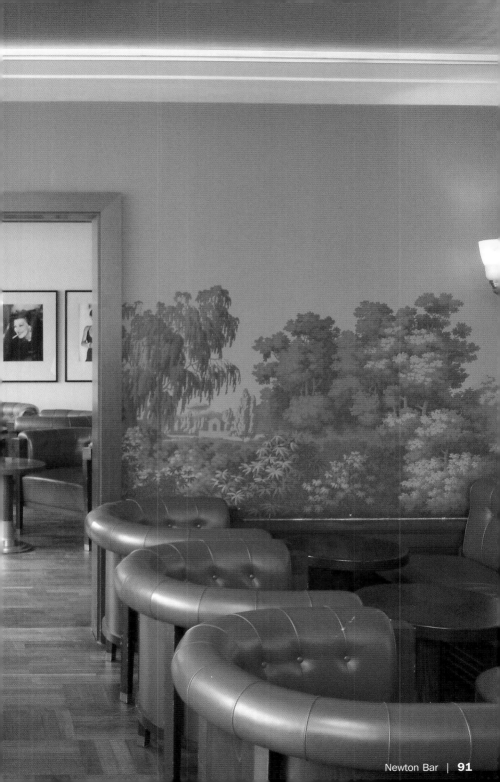

Nola's am Weinberg

Design: Andreas Müller und Soda GmbH | Chef: Stefan Schneck

Veteranenstraße 9 | Mitte
Phone: +49 30 44 04 07 66
www.nola.de | weinberg@nola.de
Subway: Rosenthaler Platz
Opening hours: Every day 10 pm to 2 am
Average price: € 15–20
Cuisine: Swiss

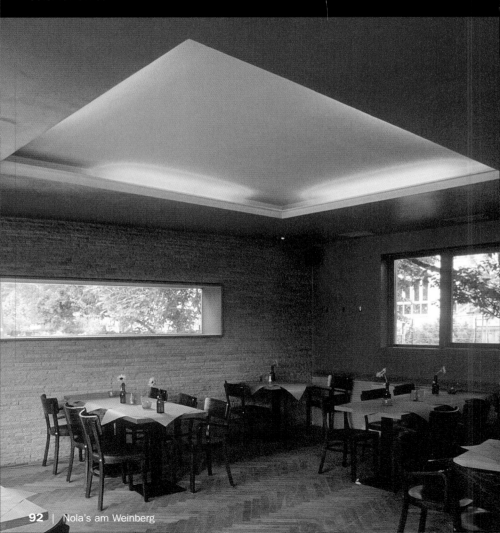

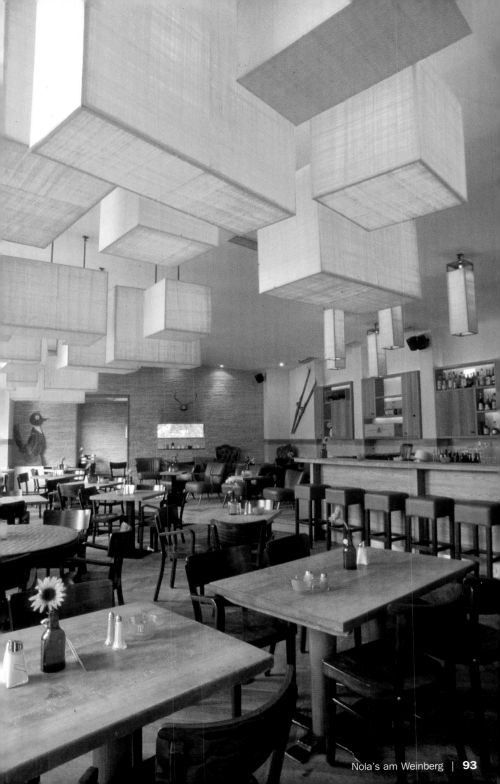

Rosenthaler Straße 38 | Mitte
Phone: +49 30 27 90 88 11
www.panasia.de | info@panasia.de
Subway: Hackescher Markt
Opening hours: Sun–Thu 12 noon to 12 midnight, Fri–Sat 12 noon to 1 am
Average price: € 9
Cusine: Asia Style | Gault Millau prized

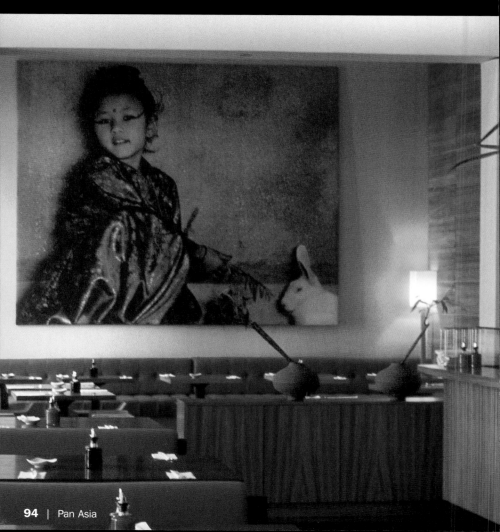

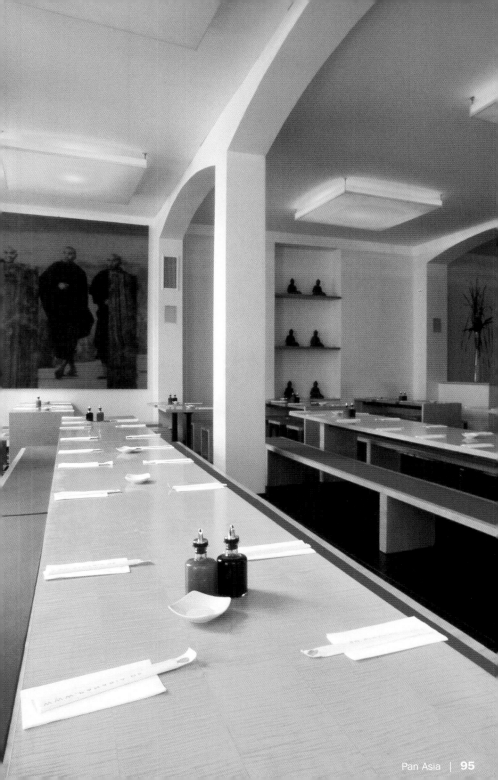

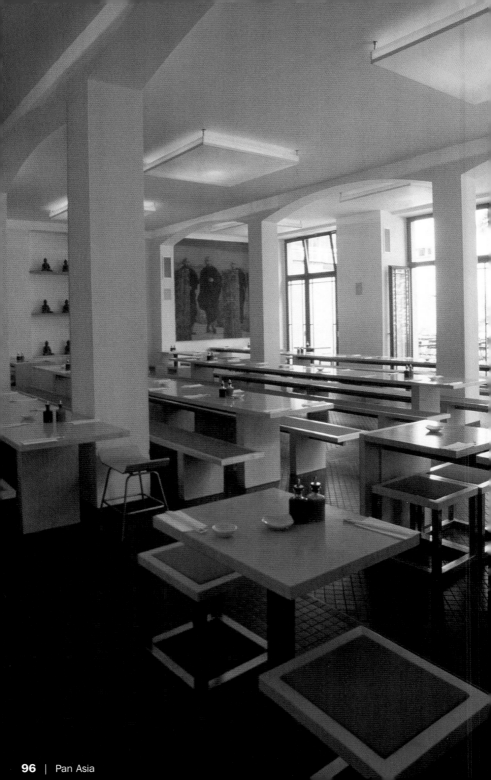

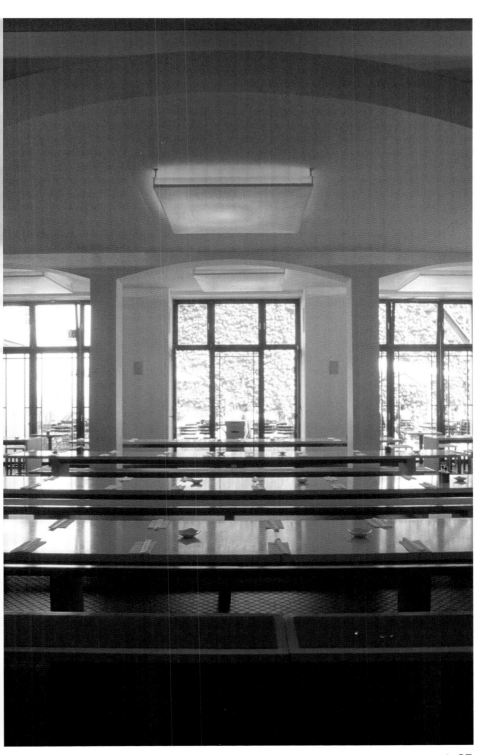

Gebratener Thunfisch

auf Wokgemüse

Seared Tuna on a Bed of Stir-Fried Vegetables

Thon saisi sur légumes au wok

Atún frito con verduras del wok

Tonno arrosto con verdura preparata nel wok

Thunfischsteak ca. 200 g
Zitronensaft, frisch gepresst
2–3 rote Zwiebeln
Mungobohnenkeime, Frühlingszwiebeln
15 Mu-Err-Pilze
Sojasauce
Chili
Koriandergrün, Salz und Pfeffer
Lauchzwiebeln

Ein schönes Thunfischsteak mit Zitronensaft beträufeln, salzen und in grob gestoßenem schwarzen Pfeffer wälzen, auf beiden Seiten scharf anbraten und ca. neun Minuten bei 90 °C ziehen lassen.

Für das Wokgemüse zuerst rote Zwiebeln gold-braun braten, dann Mangokeime, klein geschnittene Frühlingszwiebeln und Mu-Err-Pilze beigeben, kurz mitrösten, ansautieren, würzen und mit Sojasoße ablöschen. Salzen, etwas Chili beigeben und mit Koriandergrün vollenden.

Das Wokgemüse auf einem Teller anrichten und kleingeschnittene Lauchzwiebeln darüber streuen. Den Thunfisch schräg durchschneiden, auf dem Wokgemüse platzieren und sofort servieren.

Tuna fish steak, approx. 7 oz
Freshly-squeezed lemon juice
2–3 red onions
Mung bean sprouts, spring onions
15 Chinese morels
Soy sauce
Chili powder
Cilantro, salt and pepper
Spring onions

Sprinkle lemon juice on a nice tuna fish steak, salt it and turn in coarsely crushed black pepper. Sear on both sides, and bake at 200 °F for nine minutes.

For the stir-fry vegetables, first sauté the red onion until golden, then add the mung bean sprouts, finely-chopped spring onions and Chinese morels. Sauté briefly, add salt, pepper and soy sauce. Add some chili powder and garnish with cilantro leaves.

Arrange stir-fried vegetables on a plate and sprinkle with spring onions. Cut tuna steak diagonally, place on vegetables and serve immediately.

Steak de thon d'environ 200 g
Jus de citron fraîchement pressé
2–3 oignons rouges
Germes du haricot de mungo, oignons printaniers
15 champignons Mu-Err
Sauce au soja
Chili
Feuilles de coriandre, sel et poivre
Oignons printaniers

Arroser un beau steak de thon de jus de citron, saler et rouler dans du poivre noir à gros grains, saisir à vif des deux côtés et laisser reposer pendant environ neuf minutes à 90 °C.

Pour les légumes de wok, veuillez tout d'abord bien faire dorer des oignons rouges, ajoutez ensuite les germes de mungo, les oignons printaniers finement coupés et les champignons Mu-Err, blondissez un peu, sautez, épicez et arrosez à la sauce au soja. Salez, ajoutez un peu de chili et terminez par les feuilles de coriandre.

Présentez les légumes de wok sur une assiette et répandez-y les oignons printaniers. Découpez le thon en diagonale, posez sur les légumes de wok et servez immédiatement.

1 bistec de atún de apróx. 200 g
Zumo de limón, recién exprimido
2–3 cebollas rojas
Brotes de judias de mungo, cebolletas
15 setas Mu-Err
Salsa de soja
Guindilla
Hojas de cilantro, sal y pimienta
Cebolletas

Rociar el zumo de limón sobre el bistec de atún, sazonar con sal, rebozar con la pimienta machacada, freír a fuego alto y dejar reposar a 90 °C durante nueve minutos.

Para las verduras del wok, freír primero las cebollas rojas hasta que se pongan doradas, añadir después los brotes de judias de mungo, las cebolletas cortadas y las setas Mu-Err, freír y saltear unos instantes, sazonar y rebajar con salsa de soja. Salar, aregar un poco de guindilla y terminar con el verde de cilantro.

En un plato, aderezar las verduras del wok y espolvorear con las cebolletas. Cortar diagonalmente el atún, colocar sobre las verduras y servir enseguida.

Bistecca di tonno di 200 g circa
Succo di limone spremuto al momento
2–3 cipolle rosse
Germogli di fagioli mungo, cipolline
15 funghi mu-err
Salsa di soia
Peperoncino
Foglie di coriandolo, sale e pepe
Cipolline

Cospargete una bella bistecca di tonno di succo di limone, salatela e giratela nel pepe nero macinato grossolanamente. Fatela rosolare a fuoco vivace da entrambi i lati e proseguite la cottura nel forno per ca. nove minuti a 90 °C.

Per la preparazione delle verdure al wok fate friggere prima le cipolle rosse fino ad ottenere un colore ben dorato, successivamente aggiungete i germogli di fagioli mungo, le cipolline tagliate finemente ed i funghi mu-err, facendo rosolare e saltare il tutto brevemente, aggiustate e deglassatelo con la salsa di soia. Salate, aggiungete poco peperoncino in polvere e completate con il verde di coriandolo.

Disponete la verdura su un piatto e cospergetela con le cipolline. Tagliate il tonno in diagonale, adagiatelo sulla verdura e servite subito in tavola.

Kantstraße 152 | Charlottenburg
Phone: +49 30 3 13 80 52
Subway: Uhlandstraße, Savignyplatz
Opening hours: 12 noon to 2 am
Average price: € 30
Cuisine: Bistro French and classical

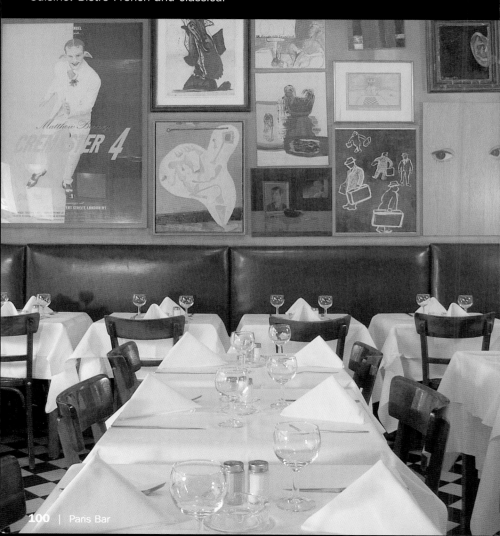

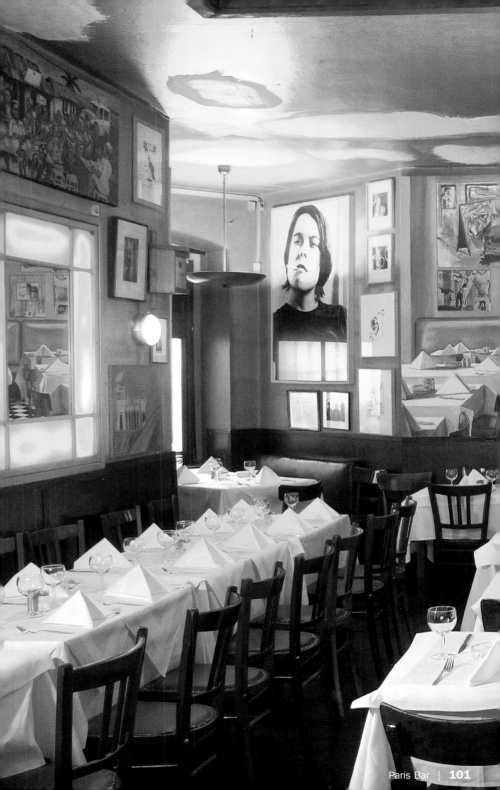

Schwarzenraben

Design: Soeren Röhrs | Chef: Christian Khalaf

Neue Schönhauser Straße 13 | Mitte
Phone: +49 30 28 39 16 98
www.schwarzenraben.de | mailto@schwarzenraben.de
Subway: Weinmeisterstraße
Opening hours: Every day 10 am to open end
Average price: € 15
Cuisine: Modern Italian

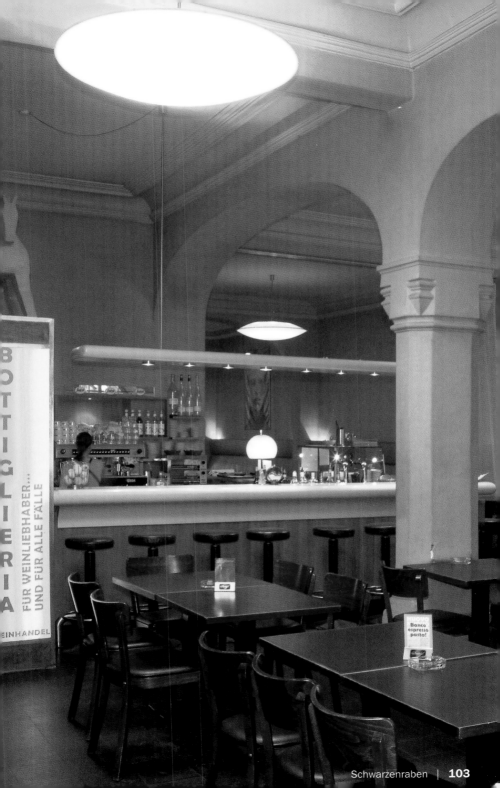

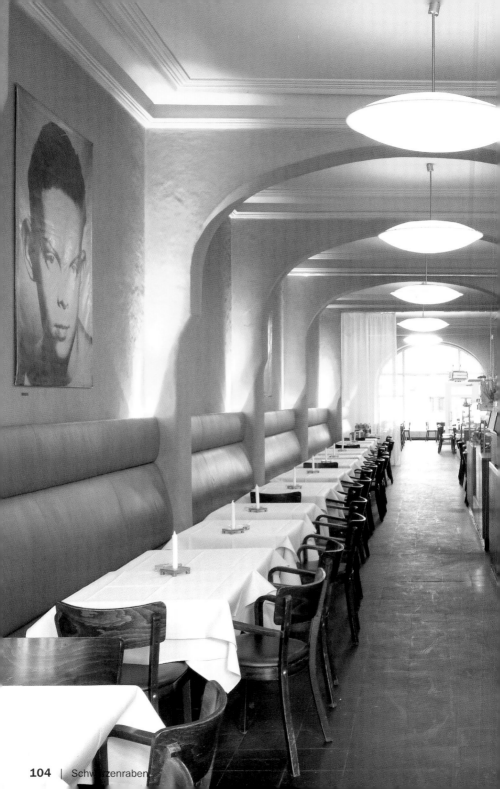

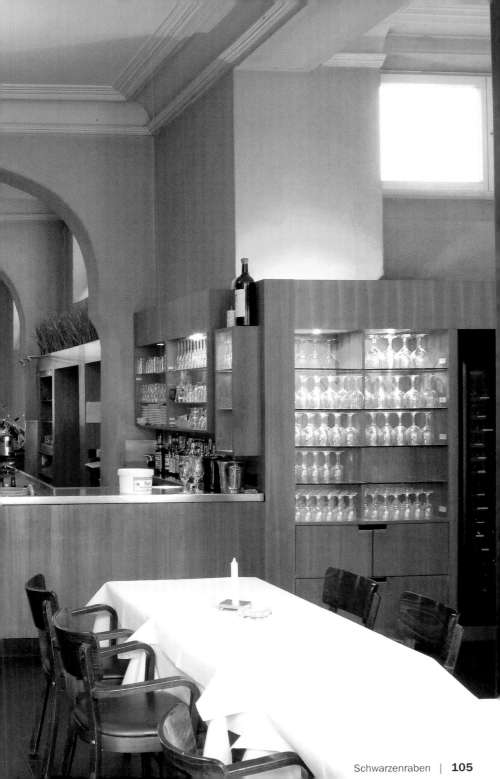

Filet vom Red Snapper
und Risotto mit grünem Spargel

Filet of Red Snapper and Risotto with Green Asparagus

Filet de vivaneau et risotto avec asperges vertes

Filete de chillo con risotto de espárragos verdes

Filetto di Red Snapper e risotto con asparagi verdi

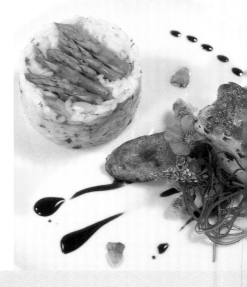

240 g Carnaroli Risottoreis
500 g grünen Spargel
4 Red-Snapper-Filets
1 Schalotte, gehackt
1 l Spargelfond
0,1 l Weißwein, trocken
Etwas Butter
60 g Parmesan
Petersilie, gehackt
Salz
Pfeffer
Knoblauch
Rosmarinzweig
Olivenöl

Spargel al dente garen und kurz abschrecken. Schalotten in Olivenöl anschwitzen, Reis dazugeben und mit erhitzen. Mit Weißwein ablöschen und verdampfen lassen. Ca. 18 Minuten unter ständigem Rühren Spargelfond angießen – jedoch Kelle für Kelle, nicht den ganzen Fond auf einmal. Zum Ende der Garzeit Spargel hinzugeben und mit etwas Butter, Parmesan und Petersilie vollenden.
In einer beschichteten Pfanne Olivenöl erhitzen, ganze Knoblauchzehe mit Schale und Rosmarinzweig hinzugeben. Die Filets auf der Hautseite bei niedriger Hitze braten, bis sich die Haut appetitlich braun färbt. Erst dann wenden und mit Salz und Pfeffer abschmecken.

8½ oz Carnaroli risotto rice
1 lb green asparagus
4 red snapper filets
1 shallot, chopped
1 l asparagus stock
100 ml dry white wine
Some butter
2 oz Parmesan cheese
Parsley, chopped
Salt
Pepper
Garlic
Rosemary sprig
Olive oil

Cook asparagus until al dente and rinse briefly in cold water. Lightly sauté shallots in olive oil. Add rice and heat. Add white wine and allow to evaporate. Slowly pour in the asparagus stock and stir constantly for approx. 18 minutes—ladle for ladle, not all at once. Towards the end of cooking time, add the asparagus and garnish with some butter, Parmesan cheese and parsley.
Heat olive oil in a coated pan; add whole garlic clove in its skin and the rosemary sprig. Fry the filets, skin side down, at low heat until the skin becomes an appetizing brown color. Then turn and add salt and pepper.

240 g de riz à risotto Carnaroli
500 g d'asperges vertes
4 filets de vivaneau
1 échalote hachée
1 l de fond d'asperge
0,1 l de vin blanc sec
Un peu de beurre
60 g de parmesan
Persil haché
Sel
Poivre
Ail
Brin de romarin
Huile d'olive

Cuire les asperges al dente et tremper dans l'eau froide. Faire blondir les échalotes dans l'huile d'olive, ajouter le riz et faire chauffer le tout. Arroser au vin blanc et laisser s'évaporer. Remuer constamment pendant 18 minutes en arrosant de fond d'asperge, néanmoins louche par louche et non tout le fond d'un coup. A la fin du temps de cuisson, ajouter les asperges, puis un peu de beurre, le parmesan et le persil.

Dans une poêle à revêtement anti-adhésif, ajouter l'huile d'olive, la gousse d'ail entière avec l'écorce et le brin de romarin. Poêler les filets à feu doux sur la face de la peau, jusqu'à ce que la peau brunisse de manière appétissante. Ne retournez alors qu'à ce moment-là et assaisonner avec du sel et du poivre.

240 g arroz de risotto Carnaroli
500 g de espárragos verdes
4 filetes de chillo
1 chalota picada
1 l de caldo de espárragos
0,1 l de vino blanco, seco
Un poco de mantequilla
60 g de queso Parmesano
Perejil picado
Sal
Pimienta
Ajo
1 ramita de romero
Aceite de oliva

Cocer los espárragos al dente. Escurrir y pasar brevemente por agua fría. Dorar las chalotas en aceite de oliva, añadir el arroz y dejar calentar todo. Rehogar con vino blanco y dejar que se reduzca. Verter, durante aprox. 18 minutos y cucharón tras cucharón, el caldo de espárragos revolviéndolo constantemente. Finalmente, agregar los espárragos y guarnecer con un poco de mantequilla, queso Parmesano y perejil.

Calentar el aceite de oliva en una sartén antiadhesiva, añadir un diente de ajo sin pelar y una ramita de romero. Freír lentamente los filetes con la piel mirando hacia abajo hasta que adquieran un color dorado apetitoso. Darles la vuelta y sazonar al gusto con sal y pimienta.

240 g di riso da risotto Carnaroli
500 g di asparagi verdi
4 filetti del Red Snapper
1 scalogna tritata
1 l di fondo di asparagi
0,1 l di vino bianco secco
Poco burro
60 g di parmigiano
Prezzemolo tritato
Sale
Pepe
Aglio
Rametto di rosmarino
Olio d'oliva

Fate cuocere gli asparagi al dente e brevemente raffreddare sotto l'acqua fredda. Fate appassire le scalogne nell'olio d'oliva, aggiungete il riso e scaldatelo insieme. Spruzzatele con il vino bianco che farete evaporare. Bagnate il riso poco alla volta con il fondo di asparagi, mescolando continuamente per circa 18 minuti – è importante non aggiungere il fondo in una volta, ma mestolo per mestolo. A fine cottura aggiungete gli asparagi e completate il tutto con poco burro, parmigiano e prezzemolo.

In una pentola rivestita, scaldate l'olio d'oliva, aggiungete lo spicchio d'aglio intero con la sua buccia ed il rametto di rosmarino. Arrostite i filetti dalla parte della pelle a fuoco moderato fino a quando la pelle avrà preso un colore ben dorato. Solo adesso giratelo, salate e pepatelo.

The Room

Design: Dag! Harbach | Chef: Nils Heiliger

Schlüterstraße 52 | Charlottenburg-Wilmersdorf
Phone: +49 30 88 00 76 66
Subway: Savignyplatz
Opening hours: Every day 6 pm to 5 am
Average price: € 12–20
Cuisine: World fusion

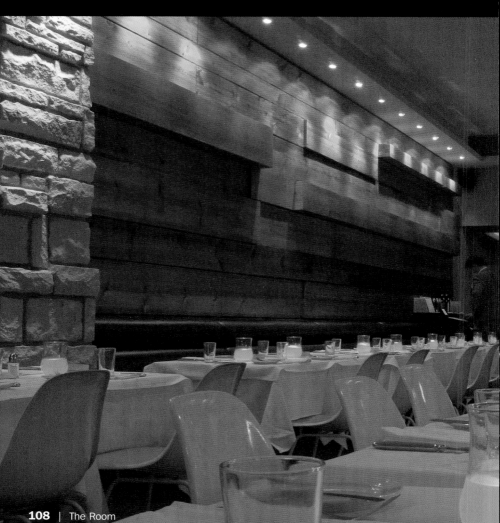

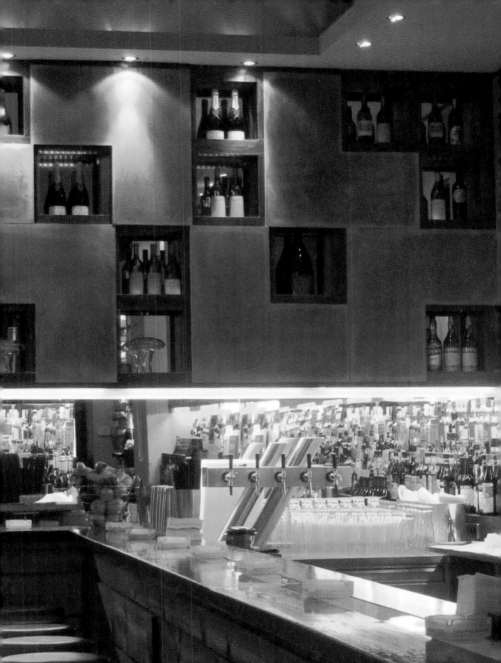

Universum Lounge

Design: Plajer & Franz Studio | Chef: Franco Francucci

Kurfürstendamm 153 | Wilmersdorf
Phone: +49 30 89 06 49 95
www.universumlounge.com | friends@universumlounge.com
Subway: Kurfürstendamm
Opening hours: Every day 6 pm to 3 am
Average price: € 9
Happy hour: Mon–Sun 6 pm to 9 pm

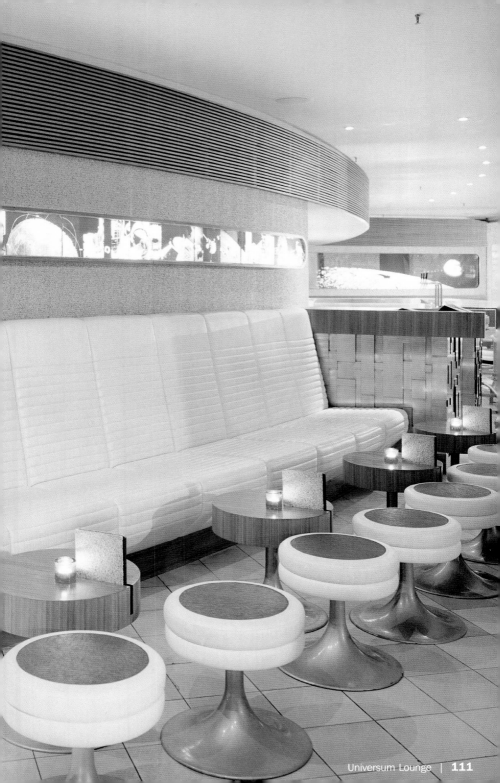

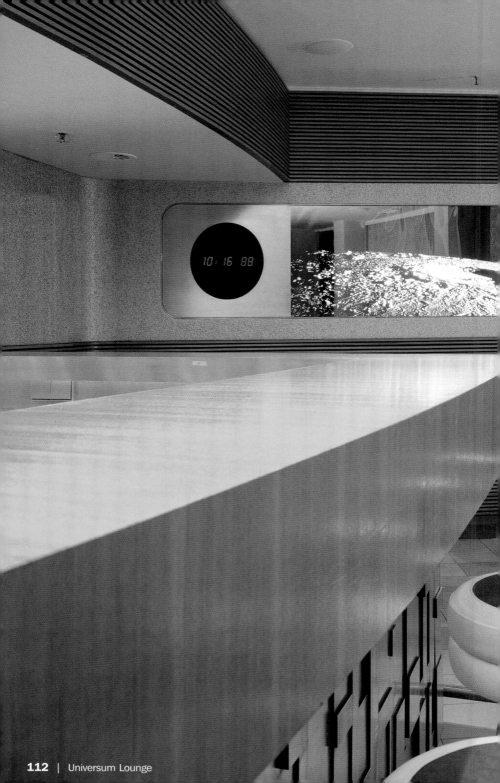

10: 16 88

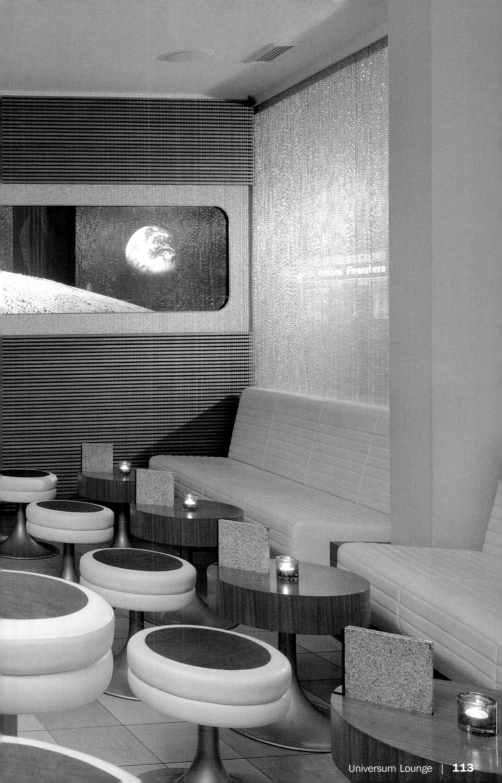

VAU

Architecture: gmp – Architekten von Gerkan, Marg und Partner
Design: Peter Schmid | Chef: Kolja Kleeberg

Jägerstraße 54/55 | Mitte
Phone: +49 30 20 29 73 0
www.vau-berlin.de | restaurant@vau-berlin.de
Subway: Friedrichstraße
Opening hours: Mon–Sat Lunch 12 noon to 2:30 pm, Dinner 7 pm to 10:30 pm,
closed on Sunday
Menu Price: € 78–115
Cuisine: International, regional

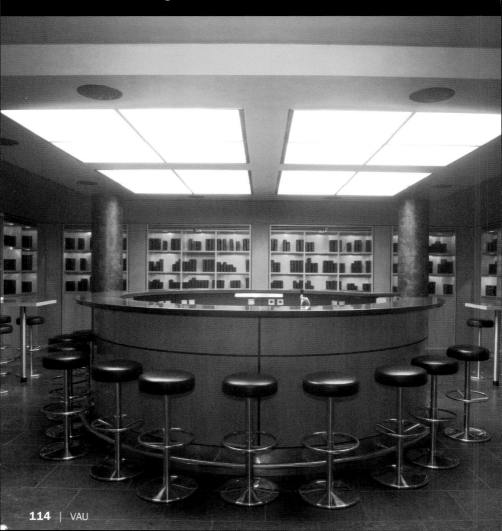

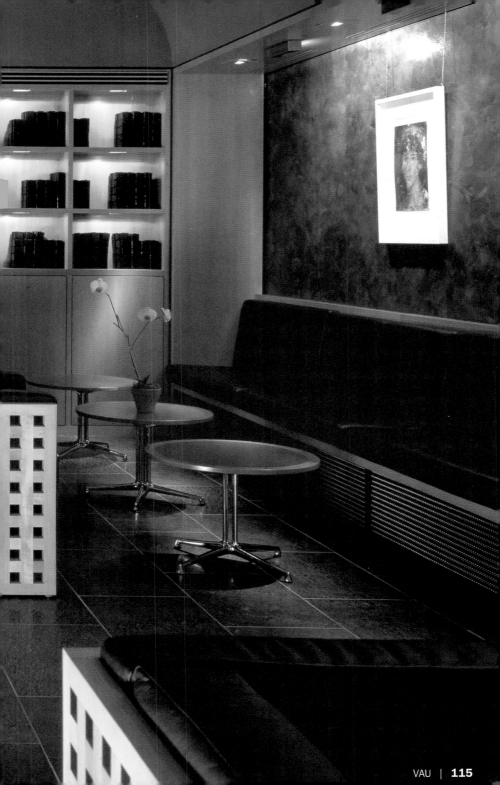

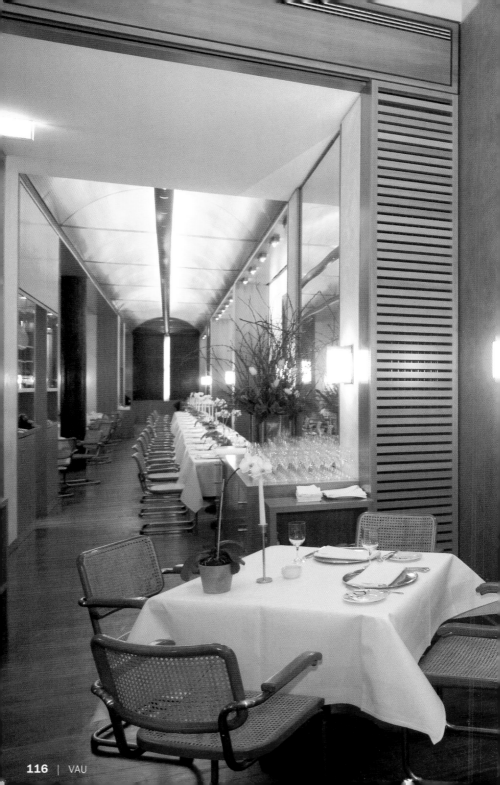

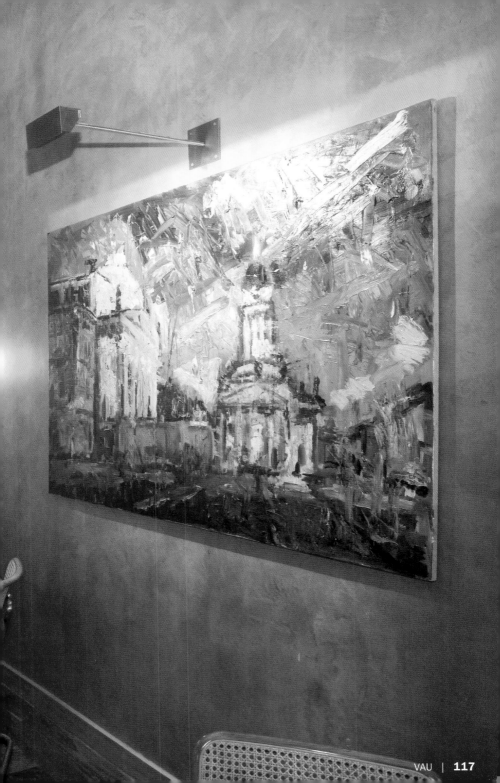

Allerlei von der Bressetaube

mit Kopfsalat

Bresse Squab Medley with Lettuce

Macédoine de pigeon de Bresse et sa laitue

Revuelto de pichón de Bresse con lechuga

Delizie del piccione di Bresse con insalata di lattuga

2 Bressetauben à 400–500 g
(mit Innereien)
4 Schalotten, 4 Champignons, etwas Stauden-
sellerie
2 Knoblauchzehen, Thymian, Rosmarin, frischer
Lorbeer, Wacholderbeeren, schwarze Pfeffer-
körner, Nelken und Piment
150 ml roter Portwein, 100 ml Wildfond
Herzen von zwei Kopfsalaten
40 g in stark gesalzenem Wasser blanchierte
junge Erbsen
1 Knolle junger Knoblauch

Die Tauben auslösen. Die Brüste (mit Haut) sowie
Herz und Leber beiseite legen. Die Karkassen
klein hacken und mit den geputzten Tauben-
keulen zusammen in einem Schmortopf anrösten.
Das geschnittene Gemüse dazugeben und mit-
rösten. Das Ganze mehrmals mit dem roten
Portwein ablöschen und mit dem Wildfond auffül-
len. Die Gewürze und Kräuter hinzufügen.

Die Taubenkeulen aus dem Ansatz nehmen,
sobald sie gar sind. Die Sauce passieren, redu-
zieren und abschmecken. Die Keulen nun wieder
in die Sauce geben.
Die gesalzenen Taubenbrüste auf der Hautseite in
eine heiße Pfanne legen und ca. eine Minute in
den Backofen (250 °C) geben. Danach die
Taubenbrüste umdrehen und ca. 10 Minuten an
einem warmen Ort ruhen lassen.
Etwas Butter in einer Pfanne erhitzen und die
ungesalzenen Innereien bei mittlerer Hitze braten.
Anschließend leicht würzen.
Den jungen Knoblauch in die einzelnen Zehen
zerteilen. Diese in gesalzener Milch zwei Minuten
blanchieren und anschließend von der Haut
befreien. Butter in einer Pfanne leicht bräunen. Die
Knoblauchzehen leicht anschwitzen. Die
geputzten Kopfsalatherzen sowie die Erbsen hin-
zufügen. Durchschwenken, leicht salzen und
anrichten.

2 Bresse squabs of 14–17 1/2 oz each
(with giblets)
4 shallots, 4 mushrooms, some celery stalks
2 garlic cloves, thyme, rosemary, fresh bay leaf,
juniper berries, black pepper corns, cloves and
pimento
150 ml red port wine, 100 ml game stock
2 lettuce hearts
1 1/2 oz young peas blanched in very salty water
1 head of young garlic

Remove squab giblets. Put breast (incl. skin),
heart, and liver aside. Finely chop the carcasses
and place in a stewpot with the cleaned legs and
sauté. Add cut vegetables and sauté with squab.
Add several dashes of port wine, and fill with
game stock. Add herbs and spices.
Remove legs from gravy as soon as they are ten-
der. Strain and reduce gravy, and add salt and
pepper to taste. Now return the legs to the gravy.
Salt breasts and place in a hot pan, skin side

down, and put pan in a 480 °F oven for one min-
ute. Then turn squab breasts and let rest for
approx. 10 minutes in a warm place.
Heat some butter in a pan and sauté the unsalt-
ed giblets at medium heat. Then salt and pepper
lightly.
Separate the cloves of the head of garlic. Blanch
them for two minutes in salted milk and then
remove skin. Brown butter slightly in a pan. Add
garlic and sauté lightly. Add cleaned lettuce heads
and peas. Toss, salt lightly, and serve.

2 pigeons de Bresse de 400–500 g
(avec abats)
4 échalotes, 4 champignons de Paris, un peu de céleri à feuilles
2 gousses d'ail, thym, romarin, laurier frais, baies de genièvre, poivre noir en grain, clou de girofle et piment
150 ml de porto rouge, 100 ml de fond de gibier
Cœurs de deux laitues
40 g de petits pois jeunes blanchis dans de l'eau très salée
1 morceau de jeune ail

Découper les pigeons. Mettre de côté la poitrine (avec la peau) ainsi que le cœur et le foie. Hacher finement les carcasses et blondir avec les cuisses de pigeons épluchées dans une daubière. Ajouter les légumes coupés et les faire blondir avec la viande. Arroser le tout plusieurs fois avec le vin rouge et verser le fond de gibier. Ajouter les épices et les fines herbes.

Retirer les cuisses de pigeon de la jonction, dès que celles-ci sont cuites. Passer la sauce, réduire et assaisonner. Remettre maintenant les cuisses dans la sauce.
Déposer les poitrines de pigeon salées sur la face de la peau dans une poêle très chaude et faire cuire environ une minute dans le four (à environ 250 °C). Retourner ensuite les poitrines de pigeon et laisser reposer pendant environ 10 minutes à un endroit chaud.
Faire chauffer un peu de beurre dans une poêle et poêler les abats non salées à feu moyen. Epicer ensuite légèrement.
Diviser le jeune ail en gousses séparées. Faire blanchir celles-ci dans du lait salé pendant deux minutes et retirer ensuite la peau. Faire brunir légèrement le beurre dans une poêle. Faire légèrement blondir l'ail. Ajouter les cœurs de laitue nettoyés ainsi que les petits pois. Faire revenir, saler légèrement et servir.

2 pichones de Bresse de 400–500 g
(con los menudillos)
4 chalotas, 4 champiñones, un poco de apio en rama
2 dientes de ajo, tomillo, romero, laurel fresco, bayas de enebro, granos de pimienta negra, clavos y pimienta de Jamaica
150 l de vino tinto de Oporto, 100 ml de caldo de carne de caza
Los corazones de dos lechugas
40 g de guisantes frescos escaldados en agua muy salada
1 cabeza de ajo tierno

Destripar los pichones. Apartar las pechugas (con la piel), el corazón y los hígados. Picar los huesos en trozos pequeños y freír unos instantes en una cazuela con los muslos limpios. Añadir las verduras cortadas y freír todo. Rehogar varias veces con el vino tinto de Oporto y cubrir con el caldo de carne de caza. Agregar las hierbas y especias.

Cuando los muslos del pichón estén en su punto, sacarlos de la cazuela. Pasar la salsa por un tamiz, reducir y sazonarla al gusto. Volver a colocar los muslos en la cazuela.
Poner las pechugas del pichón saladas con la piel hacia abajo en una sartén caliente y asarlas en el horno a 250 °C durante apróx. un minuto. A continuación, darle la vuelta a las pechugas y dejarlas reposar en un lugar caliente durante apróx. 10 minutos.
Calentar algo de mantequilla en una sartén, y freír a fuego medio los menudillos sin salar. Después, salarlos ligeramente.
Trocear el ajo tierno. Escaldar los dientes en leche salada durante dos minutos y, a continuación, quitarles la piel. Dorar ligeramente la mantequilla en una sartén. Freír unos instantes los dientes de ajo. Añadir los guisantes y los corazones de lechuga limpios. Remover todo, sazonar ligeramente con sal y aderezar en un plato.

2 piccioni di Bresse da 400–500 g cadauno
(con le loro interiora)
4 scalogne, 4 prataioli, poco gambo di sedano
2 spicchi di aglio, timo, rosmarino, lauro fresco, bacche di ginepro, grani di pepe nero, chiodi di garofano e pimento
150 ml di porto rosso
100 ml di fondo di selvaggina
I cuori di due cespi di lattuga
40 g di piselli fatti scottare in acqua fortemente salata
1 testa di aglio fresco

Disossate i piccioni. Tenete da parte i petti (con la loro pelle) nonché il cuore ed il fegato. Tritate finemente le carcasse e fatele rosolare insieme alle cosce pulite dei piccioni di Bresse in una casseruola piuttosto alta. Aggiungete la verdura tagliata e fatela rosolare. Bagnate il tutto ripetutamente con il porto rosso ed aggiungete il fondo di selvaggina. Aggiungete le spezie e le erbe.

Togliete le cosce dalla salsa appena saranno cotte. Fate passare dal setaccio la salsa, fatela ridurre ed aggiustatela. Ora immergete le cosce nuovamente nella salsa.
Adagiate i petti precedentemente salati dalla parte della pelle in una padella riscaldata ed inseriteli per ca. un minuto nel forno (a 250 °C). Dopodiché girate i petti di piccioni e fateli riposare per ca. 10 minuti in un posto dalla temperatura tiepida.
Scaldate poco burro in una padella ed arrostite le interiora senza salarle a fuoco medio. Successivamente aggiustatele delicatamente.
Dividete la testa di aglio fresco in spicchi. Fateli bollire per due minuti nel latte salato e successivamente mondateli. Fate imbiondire leggermente il burro in padella e fate appassire un poco gli spicchi di aglio. Ora aggiungete i cuori di lattuga ed i piselli. Mescolate delicatamente, salate e servite in tavola.

Victoria Bar

Design: Motorberlin | Chef: Stefan Weber

Potsdamer Straße 102 | Tiergarten
Phone: +49 30 25 75 99 77
www.victoriabar.de | info@victoriabar.de
Subway: Kurfürstenstraße
Opening hours: Every day 6 pm to 3 am, Happy hour Mon–Sun 6 pm to 9 pm
Average price: € 9
Special features: Drinks only

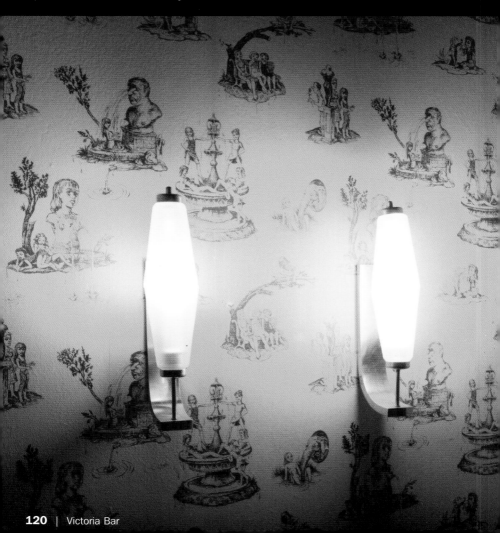

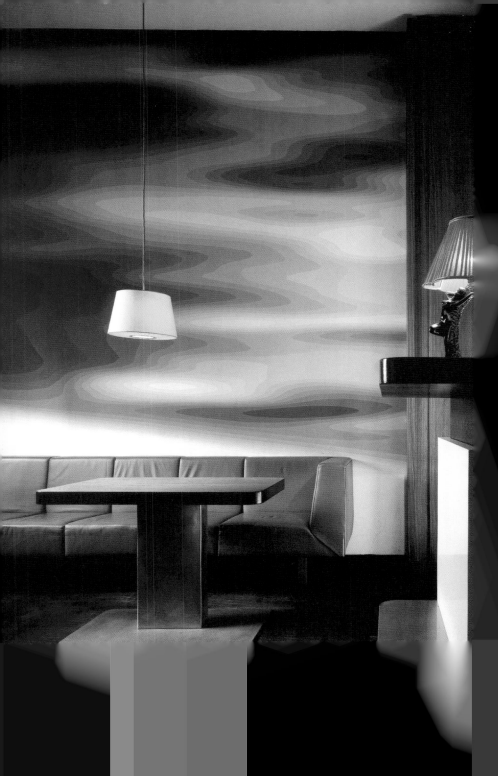

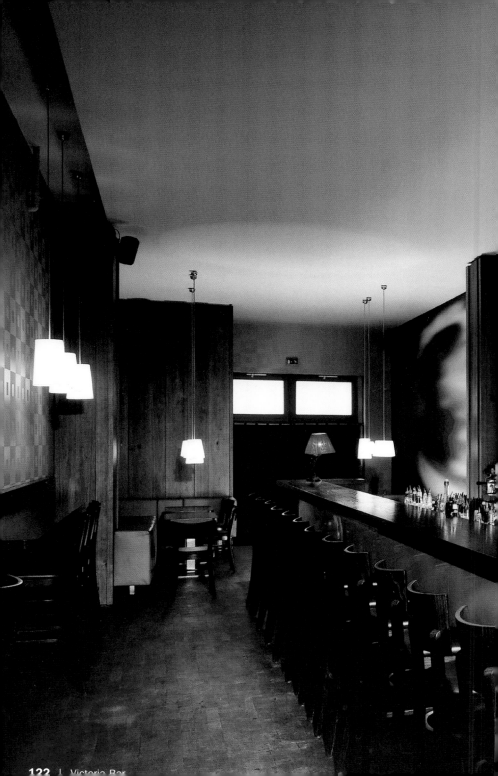

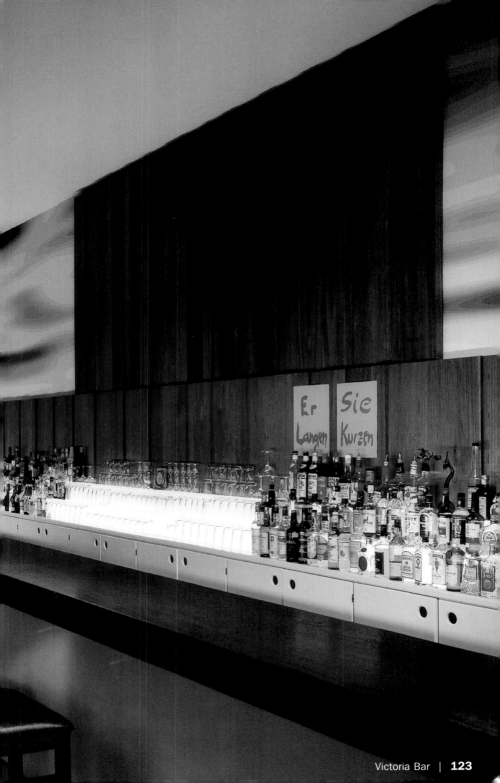

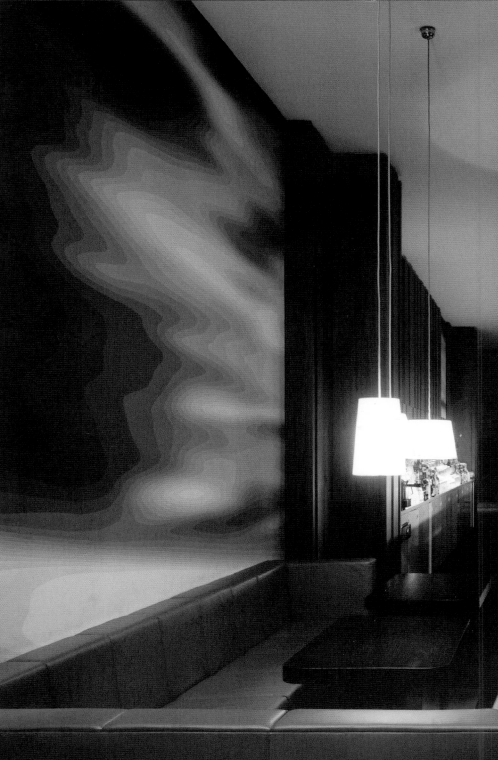

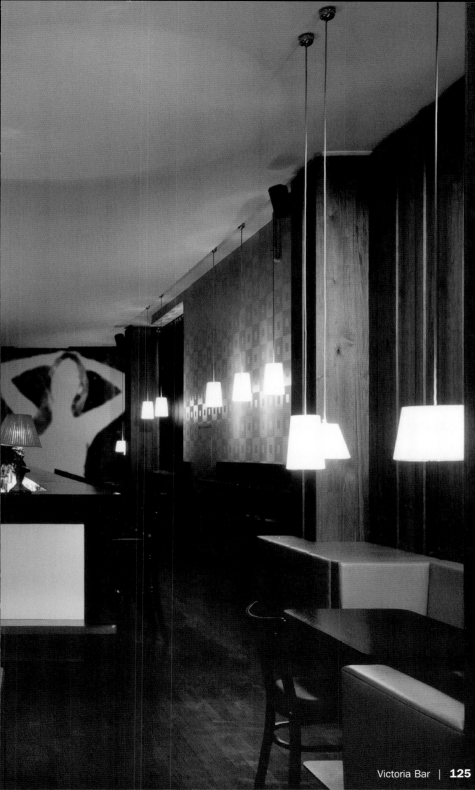

Vox Restaurant

Design: José Rafael Moneo, Hannes Wettstein
Chef: Josef Eder, Andreas Bärenklau

Marlene-Dietrich-Platz 2 | Tiergarten
Phone: +49 30 25 53 17 72
www.berlin.grand.hyatt.de | berlin@hyatt.de
Subway: Potsdamer Platz
Opening hours: Lunch 12 noon to 2:30 pm, Dinner 6:30 pm to 12 midnight
Average price: € 20
Cuisine: European, Asian

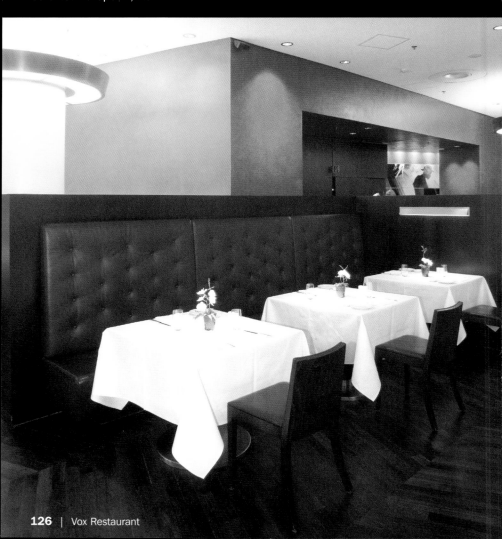

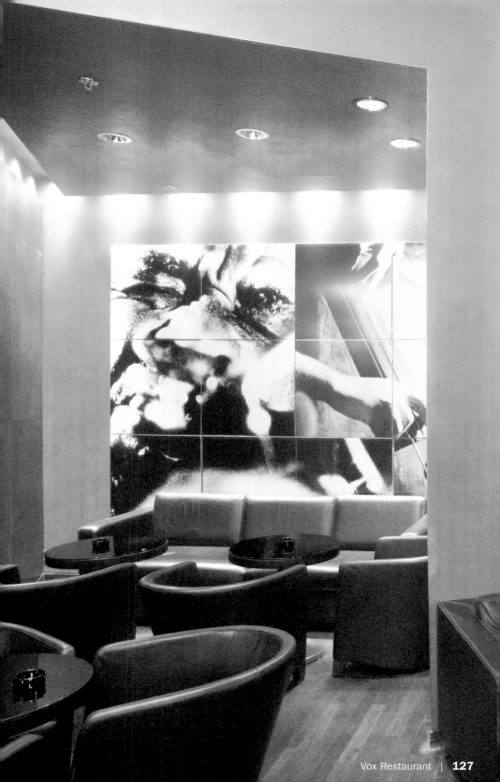

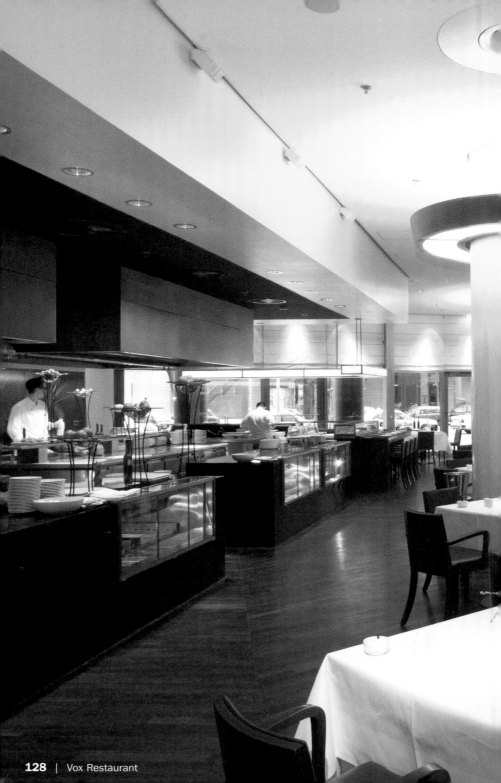

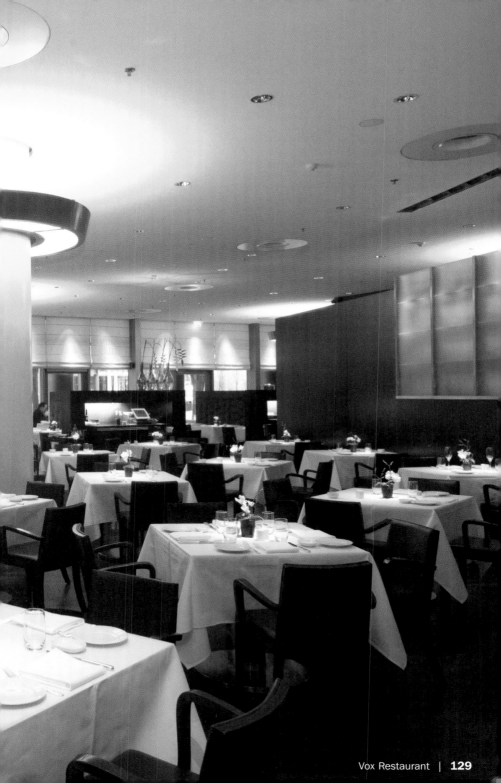

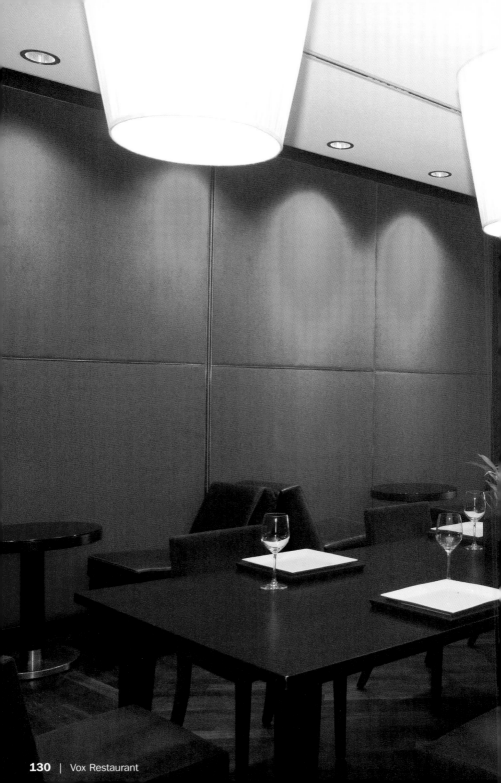

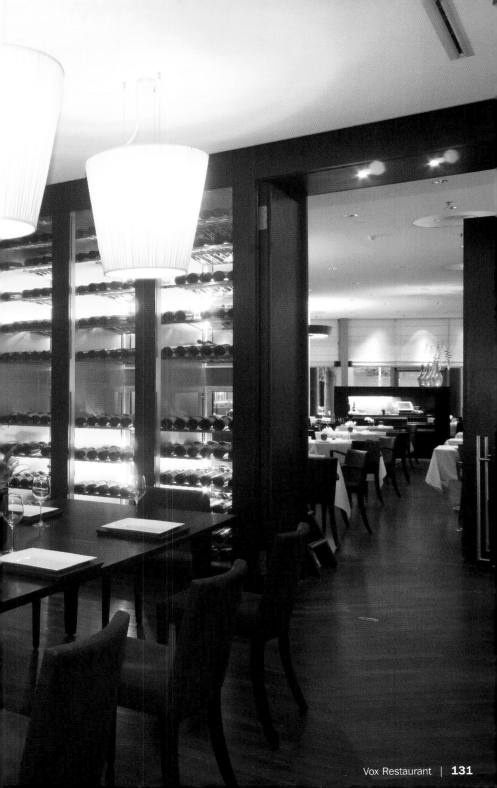

Weißer Tomatenschaum

Variationen

White Tomato Crème Variations
Variations de mousse blanche de tomates
Variaciones de batido blanco de tomate
Variazioni di mousse bianca di pomodoro

Heiße Variante (Foto)

30 ml frischer Tomatensaft (reife Tomaten pürieren und durch feines Passiertuch tropfen lassen)
3 ml weißer Portwein
2 Tropfen Tabasco
5 ml Gin
30 ml Sahne
1 TL brauner Zucker
Meersalz aus der Mühle
Kirschtomaten

Tomatensaft mit Sahne und Zucker erhitzen, 15 Minuten einköcheln lassen, mit Tabasco, weißem Portwein, Gin und Meersalz würzen, mit dem Mixer schaumig schlagen und mit Kirschtomaten anrichten.
Garnitur: Garnelen, Kartoffelgitter

Kalte Variante

30 ml frischer Tomatensaft (reife Tomaten pürieren und durch feines Passiertuch tropfen lassen)
3 ml weißer Portwein
2 Tropfen Tabasco
5 ml Gin
2 Blatt Gelatine
Meersalz

Tomatensaft mit Gin, Tabasco und Meersalz würzen, die im Portwein aufgelöste Gelatine dazugeben, auf Eis schaumig schlagen, in einen Behälter umfüllen, 30 Minuten kalt stellen und je nach Wunsch schneiden.
Garnitur: Tomatenscheiben, reduzierter Balsamico, Rucolasalat, rosa gebratenes Kalbsfilet, Parmesanscheiben, Basilikumöl, Balsamicodressing, Basilikumchips

Hot Variation (photo)

30 ml fresh tomato juice (purée tomatoes and strain through a cheesecloth)
3 ml white port wine
2 drops Tabasco sauce
5 ml gin
30 ml cream
1 tsp brown sugar
Sea salt from mill
Cherry tomatoes

Heat tomato juice with cream and sugar, simmer 15 minutes. Add Tabasco, white port wine, gin and sea salt. Using a mixer, beat until foamy. Serve with cherry tomatoes.
Garnishes: shrimps, lattice potatoes

Cold Variation

30 ml fresh tomato juice (purée tomatoes and strain through a cheesecloth)
3 ml white port wine
2 drops Tabasco sauce
5 ml gin
2 leaves of gelatin
Sea salt

Add gin, Tabasco sauce and sea salt to the tomato juice. Dissolve gelatin in port wine and beat until foamy over ice. Transfer to a container and refrigerate for 30 minutes. Cut as desired.
Garnishes: tomato slices, reduced balsamic vinegar, arugula leaves, pink roasted veal filet, Parmesan slices, basil oil, balsamic dressing, basil chips

Variation chaude (photo)

30 ml de jus de tomates fraîches (mixer les toma-
tes mûres et les égoutter à travers un torchon fin)
3 ml de porto blanc
2 gouttes de Tabasco
5 ml de gin
30 ml de crème
1 c. à café de sucre roux
Sel marin en moulin
Tomates cerises

Faire chauffer le jus de tomate avec la crème et
le sucre, faire cuire à feux doux pendant 15 minu-
tes, épicer avec le Tabasco, le porto blanc, le gin
et le sel marin, battre au mixeur jusqu'à obtention
d'une mousse et servir avec des tomates cerises.
Garniture: crevettes, filet de pommes de terre

Variation froide

30 ml de jus de tomates fraîches (mixer les toma-
tes mûres et les égoutter à travers un torchon fin)
3 ml de porto blanc
2 gouttes de Tabasco
5 ml de gin
2 feuilles de gélatine
Sel marin

Epicer le jus de tomates avec du gin, du Tabasco
et du sel marin. Dissoudre la gélatine dans le
porto, battre sur de la glace, jusqu'à obtention
d'une mousse, verser le mélange dans un réci-
pient, mettez à refroidir pendant 30 minutes et
coupez en fonction des besoins.
Garniture: tranches de tomates, balsamique
réduit, salade Rucola, filet de veau rôti à rose,
tranches de parmesan, huile de basilic, vinai-
grette au balsamique, chips au basilic

Variacione caliente (foto)

30 ml de zumo de tomate fresco (mezclar toma-
tes maduros y pasarlos por un paño fino)
3 ml de vino blanco de Oporto
2 gotas de tabasco
5 ml de ginebra
30 ml de nata
1 cucharadita de azúcar morena
Sal marina
Tomates cherry

Calentar el zumo de tomate con la nata y el azú-
car, cocer a fuego lento 15 minutos, sazonar con
el tabasco, el Oporto, la ginebra y la sal marina,
batir con la batidora hasta que esté espumoso y
aderezar con tomates cherry.
Guarnición: Gambas y patatas fritas en rejilla.

Variacione frío

30 ml de zumo de tomate fresco (mezclar toma-
tes maduros y pasarlos por un paño fino)
3 ml de vino blanco de Oporto
2 gotas de tabasco
5 ml de ginebra
2 hojas de gelatina
Sal marina

Condimentar el zumo de tomate con ginebra,
tabasco y sal marina. Disolver la gelatina en el
Oporto, batir sobre hielo hasta alcanzar una con-
sistencia espumosa. Pasar la mezcla a un reci-
piente y dejar enfriar 30 minutos y cortar al gusto.
Guarnición: Rodajas de tomate, vinagre balsámi-
co reducido, ensalada de rúcola, filetes de ter-
nera asados a punto, tajadas de parmesano,
aceite de albahaca, de balsámico vinegreta, alba-
haca crocante

Variazione calda (foto)

30 ml di succo di pomodoro fresco (frullate i po-
modori maturi e fateli gocciolare attraverso uno
strofinaccio dalla tessitura fine)
3 ml di porto bianco
2 gocce di tabasco
5 ml di gin
30 ml di panna
1 cucchiaino di zucchero di canna
Sale marino grosso da macinare
Pomodori ciliegini

Scaldate il succo di pomodoro insieme alla panna
e lo zucchero. Fatelo cuocere a fuoco basso e
ridurre per 15 minuti, insieme al tabasco, il porto
bianco, il gin ed aggiustate di sale marino. Sbattete
il liquido nel mixer fino ad ottenere una schiuma
che servirete guarnita di pomodori ciliegini.
Guarnizione: Scampi, reticelle fritte di patate

Variazione fredda

30 ml di succo di pomodoro fresco (frullate i po-
modori maturi e fateli gocciolare attraverso uno
strofinaccio dalla tessitura fine)
3 ml di porto bianco
2 gocce di tabasco
5 ml di gin
2 foglioline di gelatina
Sale marino
Aggiustate il succo di pomodoro di gin, tabasco e
sale marino. Sciogliete la gelatina nel porto e
sbattetela sul ghiaccio ad ottenere una schiuma.
Versate il liquido in un recipiente che metterete al
fresco per 30 minuti. Dopodiché potrete tagliare
la mousse nella forma desiderata.
Guarnizione: Fettine di pomodoro, aceto balsami-
co concentrato, insalata di rucola, filetto rosa di
vitello, scaglie di parmigiano, olio al basilico,
dressing di aceto balsamico, chips di basilico

Spree

Bismark-
straße
CHARLOTTENBURG

Landwehrkanal

Kantstraße

(23)(14)

WILMERSDORF

(2)(25)

(26) Ku'damm

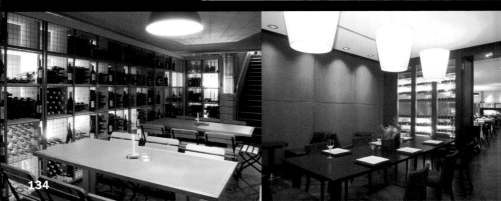

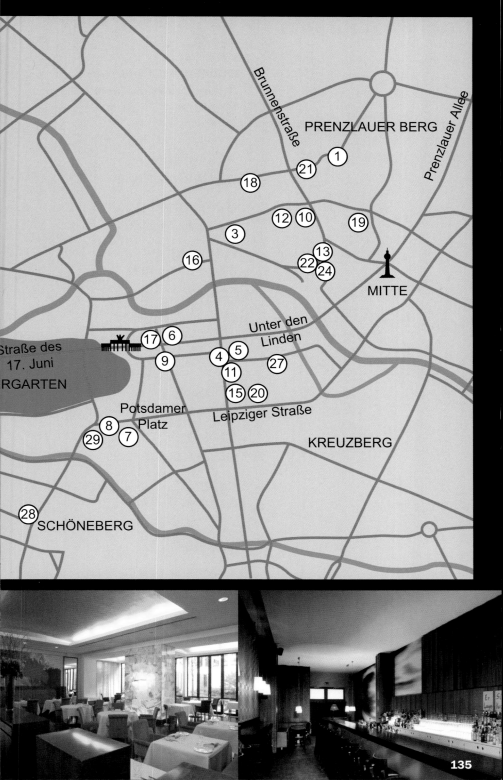